IMAGES
of America

St. Albans

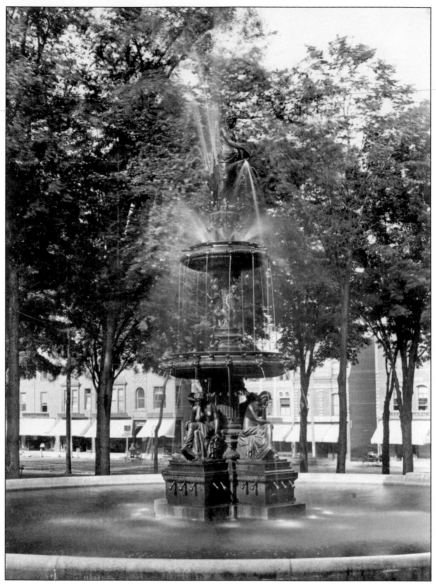

Taylor Park, peacefully situated in the middle of the city, was conceived at the same time as the village of St. Albans. Col. Holloway Taylor was one of the largest donors of land for the park that was officially named for him in 1870. In 1887, J. Gregory Smith, governor of Vermont during the Civil War, donated the fountain pictured above to ease the suffering of his "Vermont boys" who fought in the Civil War. (Courtesy of W. D. Chandler.)

ON THE COVER: Built between 1866 and 1867, the train shed, with its 88-foot width and 30,000 square feet, was designed and built by William Howe—one of the country's most celebrated contractors. The 351-foot train shed was completely open at the north and south ends, and four trains could be parked inside at one time. The headquarters building for the staff was not affected by the demolition of the train shed in 1963. (Courtesy of W. D. Chandler.)

IMAGES
of America

ST. ALBANS

L. Louise Haynes and Charlotte Pedersen
with the St. Albans Historical Museum

ARCADIA
PUBLISHING

Published by Arcadia Publishing
Charleston, South Carolina

Printed in the United States of America

Library of Congress Control Number: 2010921768

For all general information, please contact Arcadia Publishing:
Telephone 843-853-2070
Fax 843-853-0044
E-mail sales@arcadiapublishing.com
For customer service and orders:
Toll-Free 1-888-313-2665

Visit us on the Internet at www.arcadiapublishing.com

*To all past, present, and future volunteers
for your countless hours of service to the St. Albans Historical Museum*

CONTENTS

ACKNOWLEDGMENTS

We would sincerely like to thank the St. Albans Museum, from whose collection these photographs were taken. We are indebted to museum director Allyn McDonald for his support and involvement in every stage of our work. We would also like to thank the following photographers, who recorded many aspects of St. Albans's history in images: James Murphy, W. D. Chandler, Warren Hamm Sr., E. H. Royce, J. E. Moran, George Gilbert, Clarence Gilbert, T. G. Richardson, Orville Keeler, and A. F. Styles. Finally, we wish to express our heartfelt appreciation to those individuals who offered encouragement, information, and help with captions and proofreading: Jon Haynes, Don Miner, James Murphy, Gary Rutkowski and the *St. Albans Messenger*, Warren Hamm Jr., William Cioffi, Laura Gonyeau, Mark Lareau, Fred Anderson, Rabbi Joshua Chasen, Timothy Hurlbut, Daniel Rush, Gale Pewitt, John Barker, Lillian Barker, Pamela Caldwell, Sherrie Brown, Margaret Kilcourse, Dorothy and Edmund Steele, Margaret Armstrong, Lucy Ross, Gladys Neiburg, Noella Guay, and Frank L. Greene.

Images appear courtesy of the St. Albans Historical Museum.

INTRODUCTION

In 1763, after the peace treaty between France and England had settled the ownership of New England's northern lands, Gov. Benning Wentworth of the colony of New Hampshire began to issue grants of land to the west, calling them the New Hampshire Grants. His grant of St. Albans is dated August 17, 1763, to be a township 6 miles square (it is nearer 9 by 5), with exact lines to its neighbors. The first duke of St. Albans was Charles Beauclerk, and the township was either named for him or for the city of St. Albans, England. Many years later, Levi Allen jokingly addressed a letter to his wife, who was visiting the lakeshore village, "to the Duchess of St. Albans." In 1777, Vermont declared its independence from the British Empire and was, for 13 years, a "reluctant republic" before joining the United States as the 14th state in 1791.

Following the Revolution, Jesse Welden, himself a veteran of the American Revolution, moved his family to St. Albans Bay. He then moved his family to a log cabin in what is now St. Albans City. The cabin was on the west side of Main Street, near the former Houghton House. The Weldens are considered to be the first settlers of St. Albans.

In 1792, Ira Allen surveyed the route through St. Albans to the north because he was anxious to complete a way from Montreal to Boston. By 1800, St. Albans was no longer considered a mere outpost in the wilderness—a stopping place for travelers bound for Montreal. As a county seat with its strategic location insuring an escalating population, the gift of land for public use from Holloway Taylor meant that soon, handsome buildings would be erected at the village center for a courtroom, assembly, and for worship.

By 1835, there were three public docks and several private ones stretching along the bustling shoreline. H. K. Adams and others report that at about this time the place was referred to as Port Washington.

By September 1847, John Smith was president of the Vermont and Canada Railroad. Smith, Lawrence Brainerd, and Joseph Clark backed the growth of the railroad financially, and in the summer of 1851, the first train rolled into the "railroad city."

No discussion about St. Albans would be complete without mentioning the St. Albans Raid of 1864. In the latter days of the Confederacy, a plan was devised to get Union troops off the front line by forcing the government to defend its northern border. A group of Confederates, led by one Bennett Young, traveled to Canada and then into St. Albans. On the morning of October 19, they robbed three local banks, taking a sum of approximately $208,000. Shots were exchanged as the community rose to the alarm, and one person died as a result of wounds received. The raiders fled north into Canada. They were captured in Canada, but only $88,000 of the $208,000 stolen was ever returned. As a result of the raid, all three banks would eventually fail.

Through the following years, St. Albans would experience a devastating series of fires, while always recovering its beauty. It would see many of its young men off to wars overseas, suffer through the Depression years, and eventually witness the decline of the railroad. In spite of it all, however, today St. Albans remains a beautiful small city with a rich history it would like to share.

One

THE RAILROAD

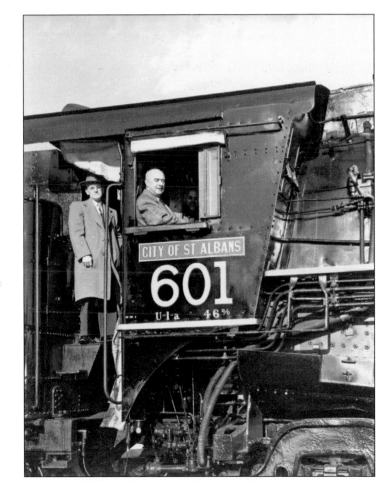

The first plans to penetrate northern Vermont by rail date from 1835. In 1843, by special act of the legislature, a charter gave the Vermont Central Railroad Company the right to build a railroad connecting points south of St. Albans. J. Gregory Smith, great-grandson of founder John Smith, is seen at the throttle of the *City of St. Albans*, named to commemorate the arrival of the first train in St. Albans on October 18, 1850.

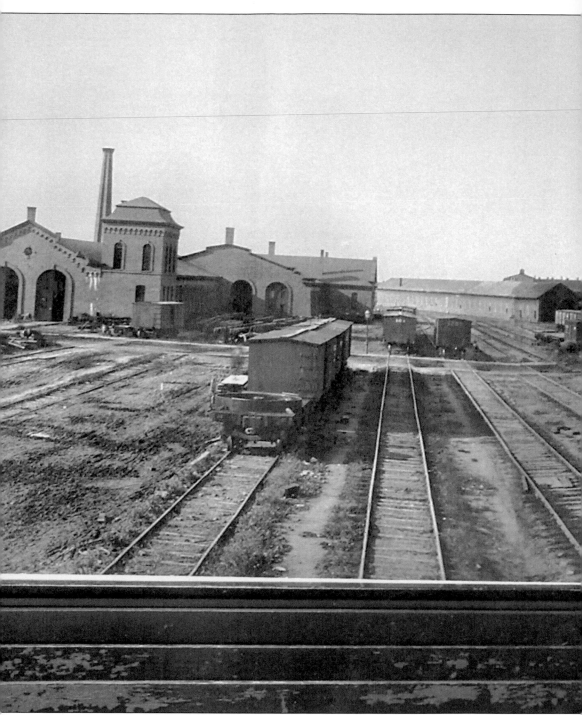

This is the heart of the Central Vermont Railway, looking north in 1875. Lake Street runs east and west where 23 sets of tracks crossed it. From the car shops at the left came completed cars. The paint shop section burned in 1923. By 1979, more shops were razed, and today a small shopping center exists there. The rear center of the photograph shows the passenger car building, which housed and protected the cars. In the right rear is roundhouse number two, built in 1866 and

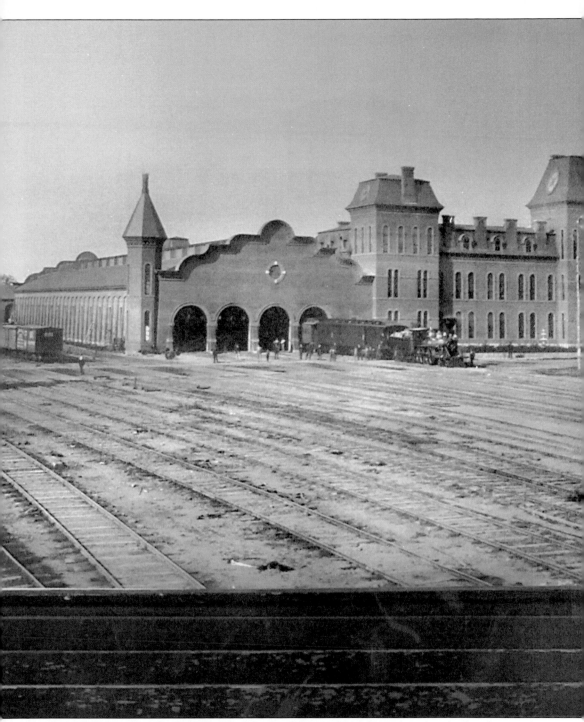

replaced by the current one in 1923. The kingly edifice at the right is the train shed and general office, built in 1866; the chimneys were removed in 1915 when central heating was installed. The tower came down in 1923, and the cavernous train shed with its four arched openings was razed in 1963. Today the general office to the right houses railroad offices and assorted companies.

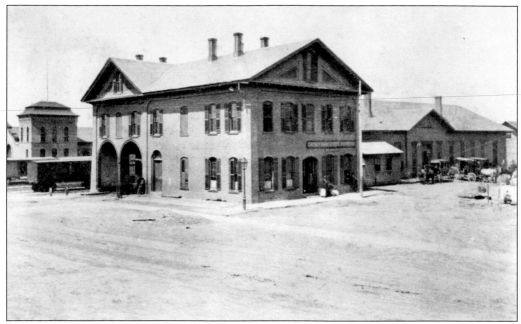

With only two tracks in the combination train shed and depot, the original Vermont Central Railroad station, built in 1851, soon became inadequate as the business grew and the town prospered. In 1866, the grand train shed and general office building replaced it. An express office is located on the right side of the building.

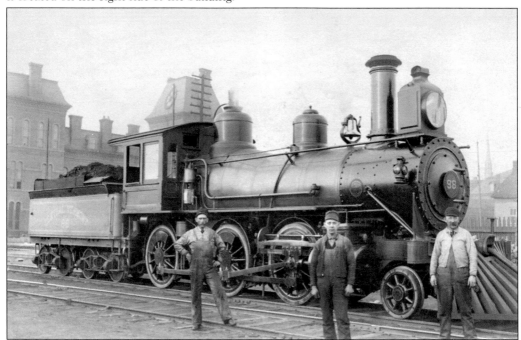

Engine No. 98 stands in the Central Vermont yard south of the general office building and train shed about 1890. The engine crew, from left to right, is engineer Will Washburn, fireman W. C. Stevens, and conductor John Brann. The Baldwin Locomotive Works built engine No. 98 in 1890, and records indicate it was scrapped in August 1920.

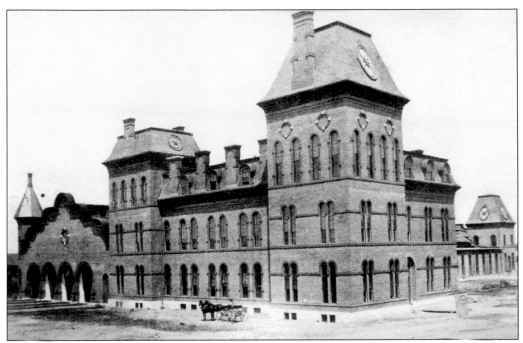

The Central Vermont Railroad Company general office building and train shed, around 1870, at the corner of Lake and Federal Streets, replaced the first depot on the site. Each room had its own fireplace, accounting for the many chimneys. Also note the tower skylights.

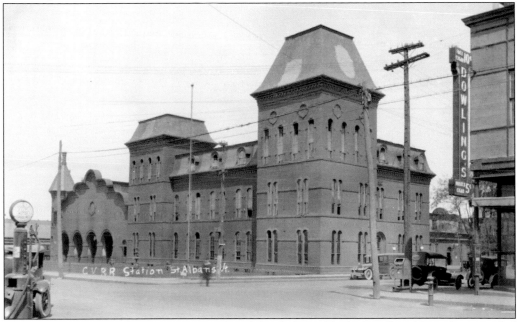

This picture shows the chimneys removed and the skylights blocked. Still visible is the extended train shed building to the north along Federal Street, which was removed in 1963. Today the former general offices are occupied by various businesses. Note the small, fenced park on the front side of the building. The Amtrak building, now open only at arrival and departure times, is a small, totally separate building to the north on Federal Street.

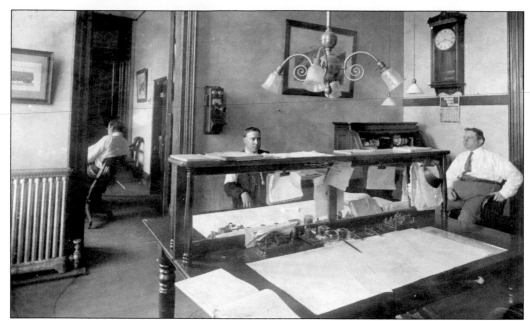

The Central Vermont dispatch office on August 30, 1908, shows the technology of its day with electric lights and telephone, but it is a far cry from the technology of rail dispatch today. From these same offices today, trains are dispatched as far away as California. The photograph is labeled on the back as once belonging to a J. P. Stevens, but it is unclear if he is one of the men in the photograph.

This photograph taken from a collection of 1908 to 1910 postcards shows a group at the Lake Street entrance to the Central Vermont Railroad train shed. Many people took day outings on the railroad to several of the not-too-distant communities, such as Swanton, Highgate, and Rouses Point, New York, via Hog Island and Alburgh, where a swing bridge was constructed after 1866 to cross Lake Champlain.

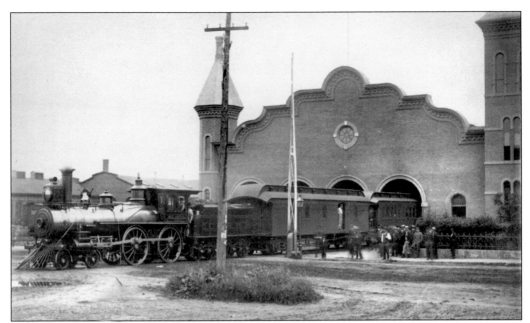

The ownership and name of the Central Vermont Railroad Company changed over the years, and in the 1960s, the station was costing $10,000 annually to maintain—too expensive for the then owner, Canadian National Railroad. It was agreed in 1963 to tear down the train shed at a cost of $9,000. This would not have happened after 1970, when the Historical Preservation Society came into being. It was found that the wood structure behind some loose bricks was sound.

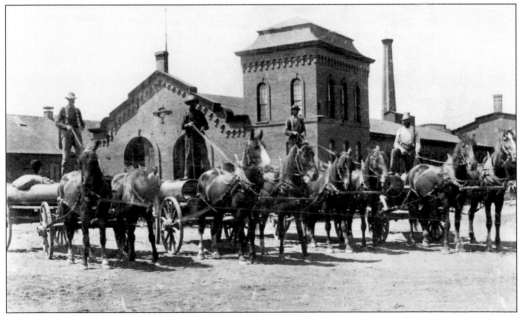

After loading their wagons with supplies delivered by train, these horse-and-wagon teams made numerous trips from the St. Albans station to the excavation site of the Fairfax reservoir around 1874. Prior to this time, fires in 1869 and 1874 persuaded the townspeople that a secure water supply would be essential. The Aqueduct Company was reorganized, procuring a 23-acre reservoir and municipal water system just east of the present site.

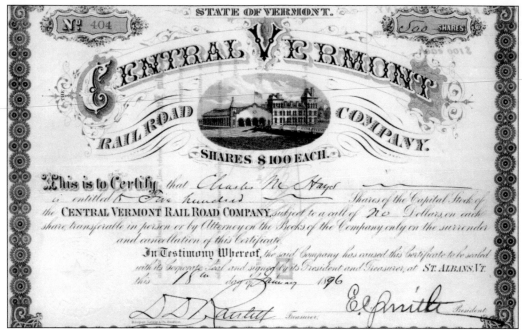

Pictured here are two railroad stock certificates offered for public sale, dated 1878 for the Vermont and Canada Railroad Company and 1896 for the Central Vermont Railroad Company. Note the Vermont Coat of Arms on the certificate for the Vermont and Canada Railroad Company, incorporated in 1845, and the picture of the general office building and train shed in St. Albans on the Central Vermont Railroad Company stock. It is interesting to note the difference in the prices of the two shares. The stock certificate above offers two interesting details: it is signed by E. C. Smith himself and it is made out to Charles M. Hayes, then general manager of the Central Vermont Railroad Company, who went down with the Titanic in 1912.

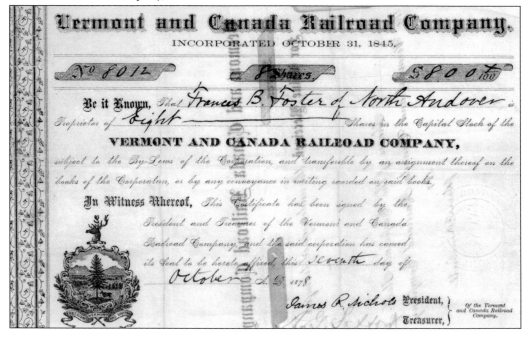

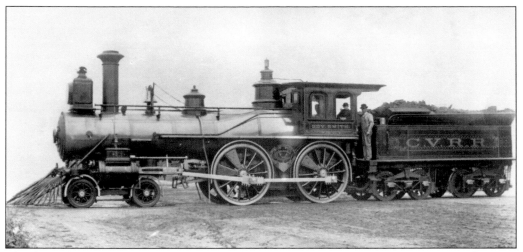

This beautiful engine was one of the Central Vermont Railroad's premier locomotives, the *Gov. Smith*. The straight-sided smoke stack indicates that this engine was a coal-burning engine. Also note the elaborate building plate between the drive wheels. However, this was not the first *Gov. Smith*. Previously there had been a wood-burning engine of the same name. It had a large smoke stack, typical of wood-burning engines, and it was highly decorated with Gothic-arched windows in the cab.

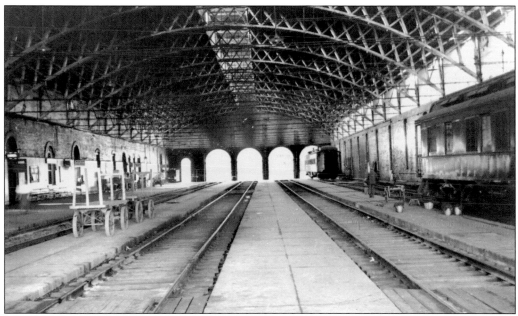

This interior photograph of the train shed gives the viewer a feel for the immensity of the structure. This permanent awning, constructed in 1866, covered four tracks and other railroad-related services. This shelter allowed passengers to board their train protected from the elements. The east-side mall housed the ticket office, a telegraph service, the American Railway Express agency, and a restaurant. At right, note the minor work being done to a passenger car.

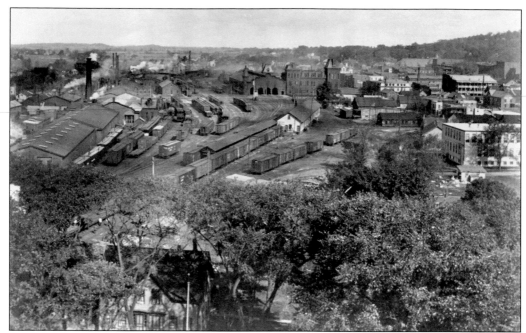

Looking north from atop the grain elevator, this photograph shows a quiet, lazy morning in the rail yard, offering a panoramic view of the area around it about 1915. Commercial buildings to the east, residential to the south, and farmland to the north capture the balance of the St. Albans area brought about by the Central Vermont Railway.

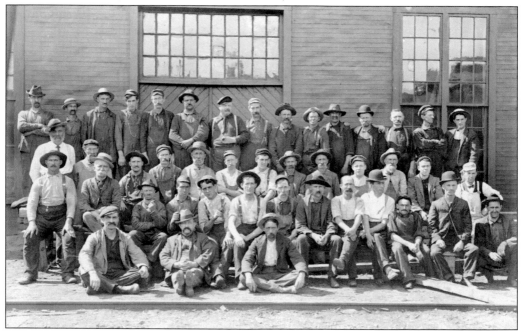

The railroad employed men of many professions: painters, welders, machinists, track repairmen, engineers, firemen, brakemen, conductors, dispatchers, porters, flagmen, office staff, and many more. This picture is taken at one of the many sheds located at the rail yard. Many of the men were of Italian descent and were hired right off the docks in Montreal.

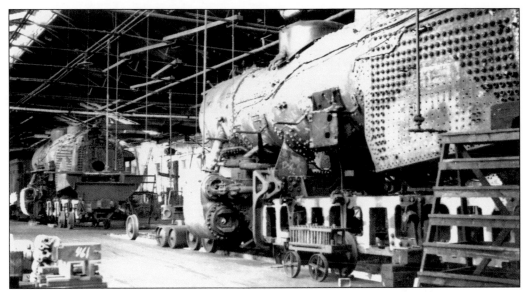

Locomotive repair in the Central Vermont Railroad shops required specialized and heavy equipment. Shown here is the underpinning of a locomotive under repair. Note the number and size of the nuts and bolts, which secure a locomotive panel to its body. Even the small, four-wheel supply cart and the six-step ladder in the right foreground echo the locomotive's sturdiness.

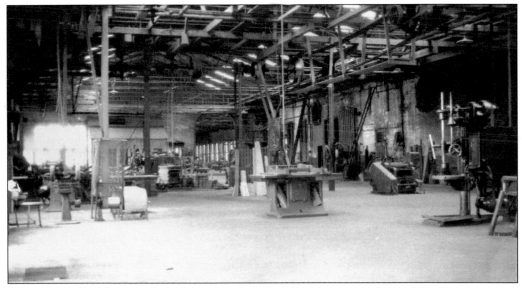

The partnership of man and machines is essential to the fabrication of parts. Metal works require sheet cutters, drill presses, and lathes, all shown here. The distance between these machines was necessary, given the size and intricate framework required to stabilize this building. Notice the belts and pulleys used to drive the machine in the center.

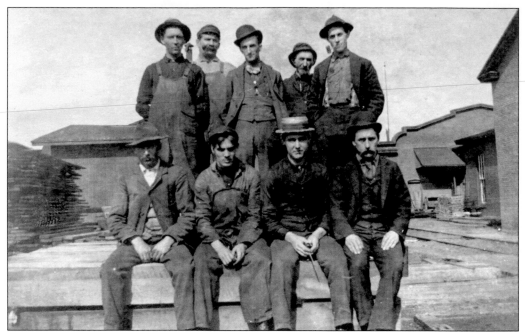

This photograph, taken around 1901, shows a small group of Central Vermont Railroad shop men. The average number of railroad employees in St. Albans in 1868 was 1,750. The importance of the railroad in the labor force is realized when considering that the population of St. Albans in 1870 was only 7,014. Among these men were electricians, welders, painters, and other laborers required in the repair shops.

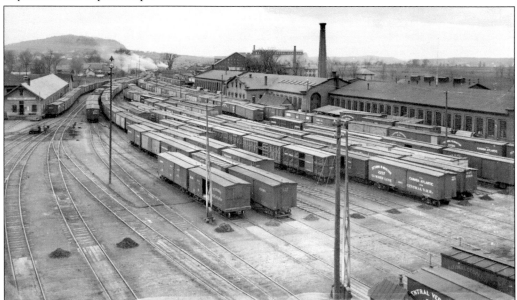

This view of the train yards, looking south towards Nason Street, was called Bear Town by the railroad men, though the origin of the name remains a mystery. To the left of the tall smoke stack, the sprawling building with windows is the rolling mill that manufactured rails for the railroad. Wirthmore Feed was one of the many businesses in town using the railroad to transport its products. The hill in the distance is Prospect Hill.

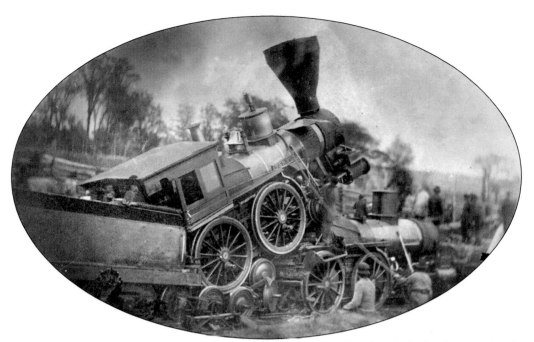

On May 20, 1864, the wood-burning *Vermont* passenger train collided with the freight train *Sorelle* just west of the Italy Yard near the Brigham Road crossing. The engineer of the *Sorelle* died in the wreck, but the *Vermont* engineer leaped from his locomotive in time. The *Vermont* kept its name throughout its service.

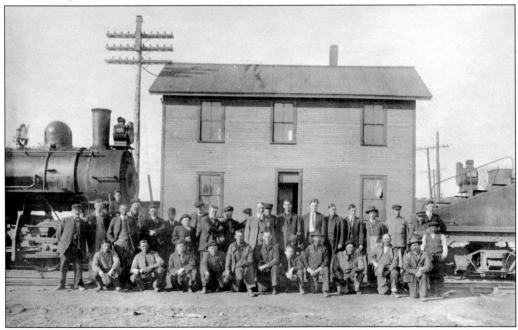

The Central Vermont Railroad referred to this area northwest of the general offices as Italy Yard. It is believed that many of the Italians involved in the construction lent the name of their homeland to this site. Italy Yard became the main switching area for the railroad in the 1890s. Among the men in this photograph can be found engineers, flagmen, yard conductors, and brakemen.

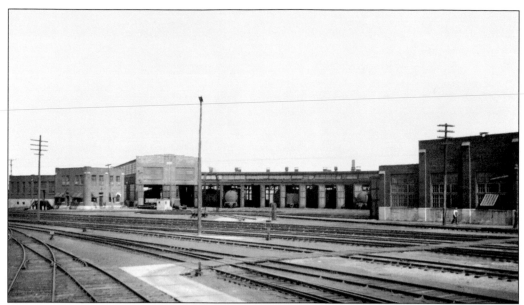

The engine house built in 1923 is shown here in 1930. It is here that locomotives were serviced and repaired. While much of the servicing and small repairs were completed in the tall section of the building at the right, major locomotive work was done in the tall structure on the left. Serviced locomotives were then placed in the bays at the center until needed.

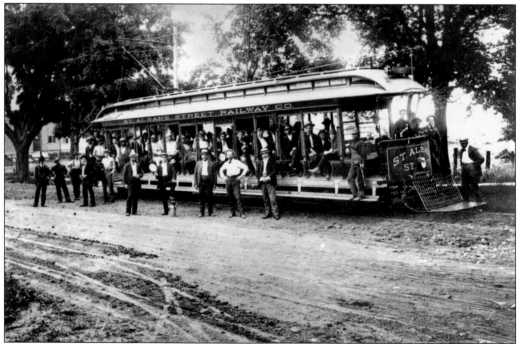

The electric railway opened with great fanfare on July 4, 1901, after a trial run on July 2 and a ceremonial run on July 3. The trolley ran from the St. Albans Bay dock for passenger and freight boat connections through St. Albans and on to Swanton Town Square. This event coincided with another major event in 1901. The Lake Champlain Transportation Company's steamer *Chateauguay* docked for the first time at St. Albans Bay. Notice the people catcher at the front.

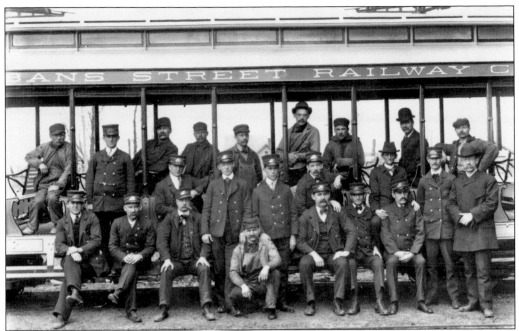

Employees of the St. Albans Street Railway Company pose for a photograph on July 4, 1901. Residents used this service for a variety of business and pleasure outings. In the early 1900s, the network from St. Albans Bay to Swanton became known as the St. Albans and Swanton Traction Company. The street railway was closed in 1921, and the tracks were taken up for scrap during World War II.

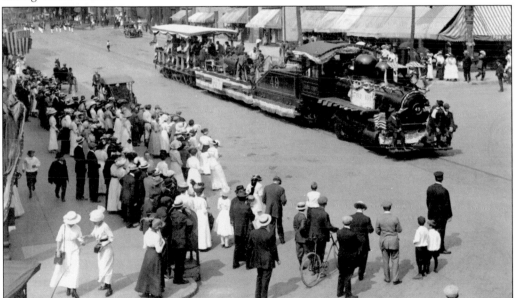

Any parade was a draw for the people of St. Albans and the surrounding towns, and this parade on July 16, 1913, was in celebration of the grant issued to St. Albans on August 17, 1763, by Royal Governor Benning Wentworth of New Hampshire, making it a township following the surrender by the French in Canada to Britain. The 60-pound rails used by the Street Railway could support a steam locomotive, allowing the use of the tracks for such celebrations as this.

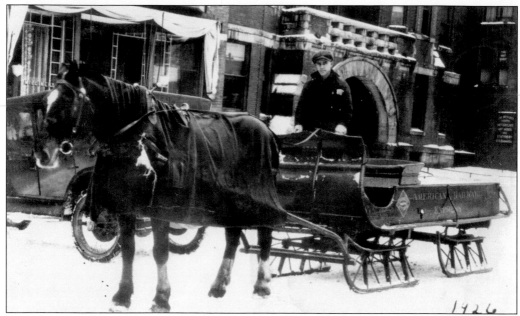

1926

This 1926 photograph shows Freddie Mosher and his horse prepared for winter weather while out on a delivery. Freddie drove for the American Railway Express Company for 20 years, and on this day he had just passed the current St. Albans City Hall. Also seen in the photograph is a sign for a millinery shop. Even without snow tires or chains, an automobile has made its way downtown on a winter's day.

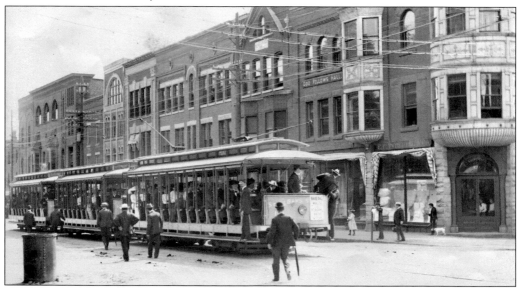

The St. Albans Street Railway Company cars shown here are providing transportation as a baseball special for a game pitting St. Albans against Malone, New York. Note the many interesting architectural features of the west side of Main Street between Kingman and Lake Streets. This line also made daily connections with the Lake Champlain Transportation Company steamers the *Ticonderoga*, the *Vermont*, and the *Chateauguay* at St. Albans Bay. Many excursions were enjoyed on the lake steamers. Next to the dock, as an end-of-the-line attraction, was the floating aquatic theater.

Two

THE ST. ALBANS RAID

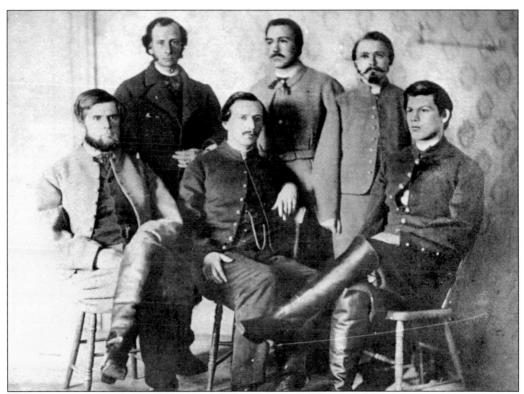

On October 19, 1864, St. Albans became the northernmost site to be attacked by the Confederates. Bennett H. Young was the leader of 21 additional rebels, and their attack was to sow serious doubts about Lincoln's chances of receiving an early peace through military victory. This photograph, taken around February 15, 1865, shows some of the men. From left to right are (first row) William H. Huntley, Marcus A. Spurr, and Bennett H. Young; (second row) Stephen F. Cameron, Charles M. Swager, and Squire T. Tevis.

$10,000 REWARD!

The St. ALBANS BANK and THE FIRST NATIONAL BANK of St. Albans, Vt. were robbed by an armed band of raiders, on the 19th Oct. 1864, of the following notes and bank bills, viz:

4 1000's U. S. 7.310 Treasury Notes, Nos. 18681 to 18684, inclusive,
20 500's do Nos. 28085 to 28101, inclusive; and also 1715.
100 100's do Nos. 184.075 to 184.172, inclusive and also Nos. 142.563; 145.574
105 50's do Nos. 16295 to 16296, inclusive; 20.587 to 20.640, inclusive.
 30.088 to 30.096, inclusive. 131.360 to 134.360, inclusive
 and also Nos. 20.645 and 20.646; also, 20.665 to 20.673, inclusive, and No. 25,081.
And also 6 1281 bonds, payable to A. Sowles, Cashier. Number 7,927 to 7,354

All payable to blank, order; all dated August 15, 1864. Also, $10,000 5 per cent. legal tender coupon U. S. Notes, dated December 1, 1863, with one coupon taken off, of the denominations of 50s and 100's. Also, $4,000 6 per cent. U. S. interest bearing notes. Also, $1,000 6 per cent. compound interest notes. Also, $9,000 in St. Albans and Franklin County Bank Bills and Greenbacks, and some other New England Bills.

$19,000 U. S. Legal Tenders. 4,000 do do interest bearing notes 10s, 20s, 50s, and 100's. Four $500 6 per ct. compound inst. notes. 8000 New England Bank bills. 5000 N. Y. State bank bills.

All persons are hereby cautioned against purchasing any of the above described Government notes, as payment has been stopped by the U. S. Government. The above reward will be paid for the return of the same to S. Browning, Esq., Ottawa Hotel, Montreal, C. E., or to the undersigned, and no questions will be asked, and no names disclosed. A just proportion of the above reward will be paid to any person who will return any part of the above described notes and bills, not already in the hands of the Canadian authorities.

H. E. SOWLES, President St. Albans Bank.

HIRAM BELLOWS, President First National Bank.

St. Albans, Vt., October 26, 1864.

The raid on St. Albans in October 1864 netted the rebels some $208,000 from the St. Albans Bank, the Franklin County Bank, and the First National Bank. The amount would be about $3.2 million today. The information in the reward helped modern auditors to determine the actual amount gleaned during those robberies. At the time, the president of the First National Bank was Hiram Bellows (who would later leave railroad stock to establish a secondary school in St. Albans, which would become Bellows Free Academy–St. Albans).

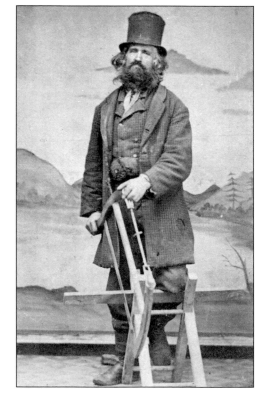

Much has been written about the St. Albans Raid on October 19, 1864, when a small band of Confederate soldiers met in St. Albans to relieve the banks of their money. The raiders were divided into small groups assigned to each of three banks, where they demanded money, silver, and gold. Jackson Clark, pictured here, a wood sawyer, was in the Franklin Bank at the time of the robbery and was locked in the vault, along with the cashier, Marcus Beardsley.

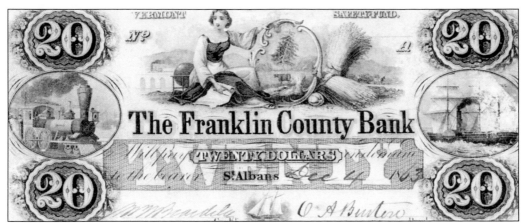

This bank note is a copy of the currency that Confederate soldier Marcus Spurr took from the Franklin County Bank during the St. Albans Raid. It was reported that he kept a small amount as souvenirs, and in 1964, his descendents sent $69 in original Franklin County bank notes back to St. Albans in denominations of $1, $2, $5, $10, and $20 bills. These might have been lost to history but for the quick thinking and intervention of St. Albans resident Robert Houghton, who purchased them and donated them to the St. Albans Historical Museum.

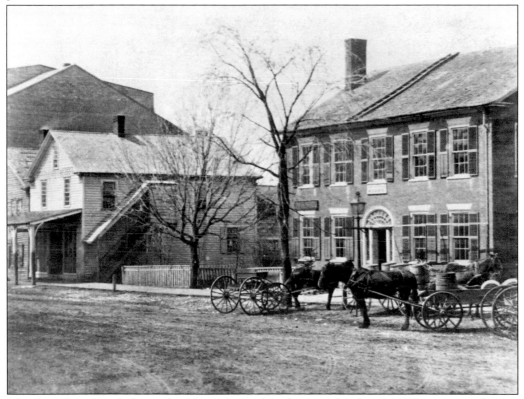

The St. Albans Bank, located to the right in this photograph taken in 1867, was one of three banks attacked by the rebels. Bank teller C. N. Bishop was counting and sorting bank notes when the men entered, and soon two of them had their pistols pointed at him. A customer named Samuel Breck then entered the bank and was relieved of $393. Different amounts were claimed lost during the raid, but $80,000 was the accepted amount.

The Franklin County Bank was just down the street from the St. Albans Bank. Soon the walk-in vault and counter drawers were emptied, and bank employees were forced into the walk-in vault and locked in. Luckily they were soon released from the airtight vault. The approximate amount lost was $70,000. During the attack, the soldiers had intentions of burning the depot and all public buildings.

The First National Bank, located just to the left of the Park View hotel, was the third of the simultaneously planned attacks on banks. Raider Caleb Wallace drew his pistol on cashier Albert Soules, threatening his life if he did not cooperate. After they gathered cash and treasury and promissory notes, in their haste they appear to have left behind more than they had taken. This bank was robbed of around $58,000.

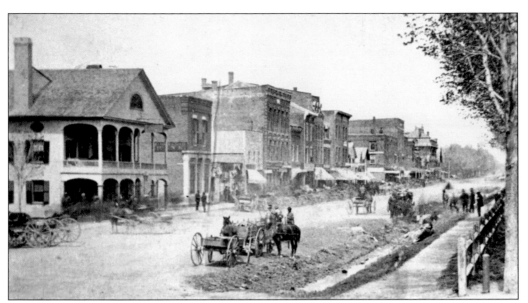

The above photograph shows Main Street looking north from the bottom of Fairfield Street in the 1860s. Some of the Confederate soldiers lodged at the American House, which can be seen at the left. The Franklin County Bank is to its immediate north. The Village Green, seen to the right, was where some of the soldiers corralled civilian prisoners during the raid. Note the number of wagons lined up in front of the various businesses on market day, the day before the raid. The photograph below depicts the American House in the 1870s at the corner of Lake and North Main Streets. Note the sign for the Commercial Union Telegraph Company.

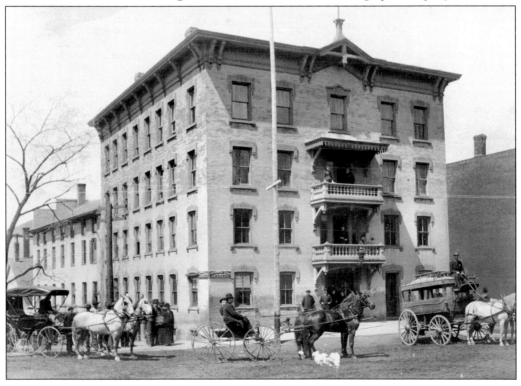

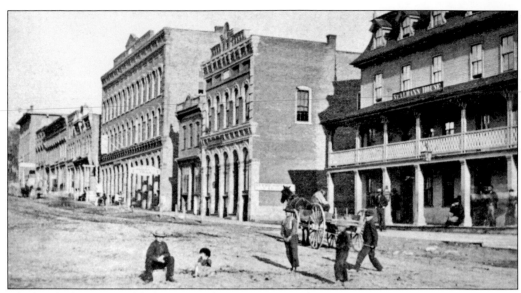

The band of raiders trickled into St. Albans by train and coach, a few at a time, and were in and about the village up to the time of the raid to observe the daily routines of the people of St. Albans, the locations of the banks, and the livery stables where horses could be obtained when they would be ready to leave. Bennett Young, the leader, arrived on October 10 and lodged at the Tremont House, the site of the present city hall. It was reported that Young was a diligent oral reader of the Scriptures. The above photograph shows the St. Albans House on the corner of Lake and Catherine Streets. It is known that a spare room here was part of the Underground Railroad.

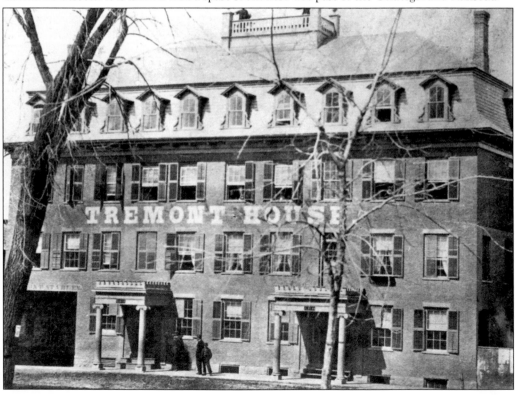

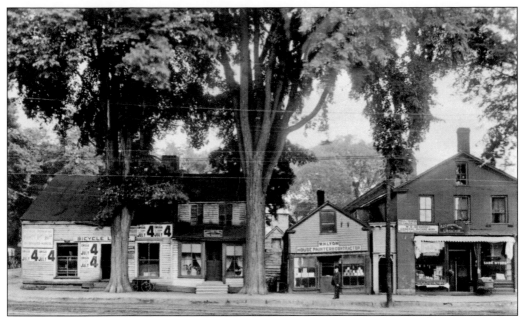

This 1901 W. D. Chandler photograph shows the corner of North Main and Congress Streets facing east. It shows E. D. Fuller standing on the sidewalk approximately where Elinus J. Morrison of Manchester, New Hampshire, was shot by Bennett Young. Morrison, who was in St. Albans working on construction of the Welden House, died of his injuries on October 21, 1864. Today Moonshadows and Howard's Flower Shop can be seen at this location.

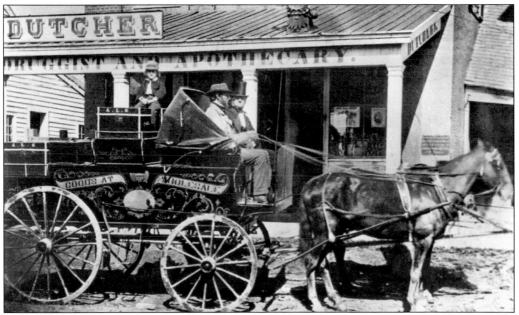

On October 19, 1864, Dutcher's Drug Store and Apothecary served an unusual customer. During the chaos of the St. Albans Raid, Elinus J. Morrison of Manchester, New Hampshire, tried to duck into Miss Beattie's Millinery Shop but was hit by a Bennett Young bullet, which passed through his hand and lodged in his abdomen. He was carried into Dutcher's Drug Store, where he was treated. He was later taken to his lodgings at the American House, where he died two days later.

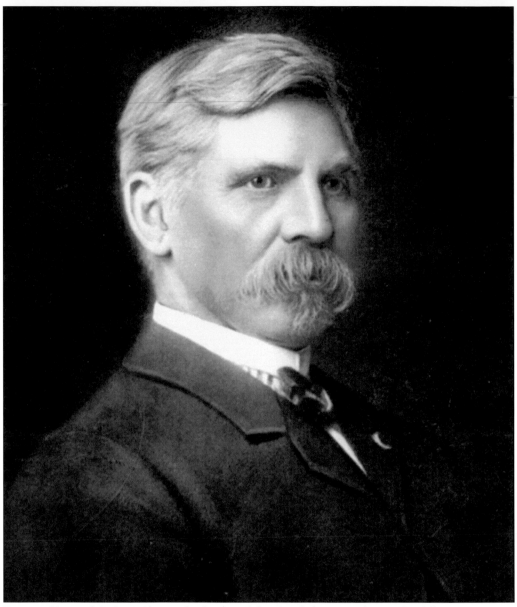

Bennett Young (1843–1919) was the leader of the Confederate raiders in St. Albans. He was a Kentuckian with very strong Southern sympathies. He left college to enlist in Company B, 8th Kentucky Cavalry in 1862 and was captured in Ohio in 1863. He was imprisoned at Camp Douglas in Chicago but soon escaped to Canada where he resumed his studies for the ministry. In 1864, he evaded a federal blockade and went to Virginia, where he was commissioned as a first lieutenant in the provisional army of the Confederate states. He returned to Canada and eventually organized his own company to raid northern border communities, the most notable being St. Albans on October 19, 1864. After the war, Bennett Young eventually returned to Louisville and for the remainder of his life enjoyed business and social success in law and as a developer of the Monon and Louisville Southern Railroads. His humanitarian accomplishments include the Louisville Free Public Library, the Negro Orphan Home, and the Kentucky School for the Deaf. During his years as a popular lecturer, he rarely spoke about the St. Albans Raid.

Three

THE GREAT FIRES

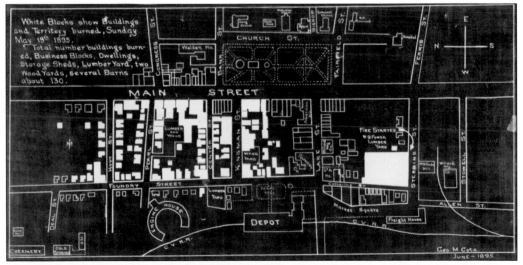

There have been several devastating fires in St. Albans over the years. The fires of 1869 and 1871 prompted the village fathers to persuade the townspeople to secure a water supply and reservoir in Fairfax, which was constructed in 1874. This map shows the results of the fire of 1895, which began at the Fonda Lumber Yard on the corner of Stebbins and Catherine Streets and spread northward, devastating the business district.

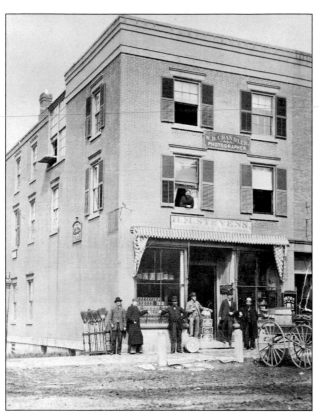

The view of the southwest corner of Main and Kingman Streets around 1882 depicts two well-known businesses on Main Street. This block survived the devastating fire of 1895 and remains much the same today. The sign on the Kingman Street side of the building advertises the dentistry office of Dr. John Sheerar, located in the Peoples Trust building just down the street.

This photograph shows Main Street around 1870, prior to one of St. Albans's most destructive fires. Many buildings were destroyed in the fire of September 7, 1871. It began on the west side in back of Johnson and Dunmore's Store and spread to Gilmore and Brainerd's Livery Stable. The Tremont House, seen here, would succumb to fire in 1895, and the present-day city hall is now on that site.

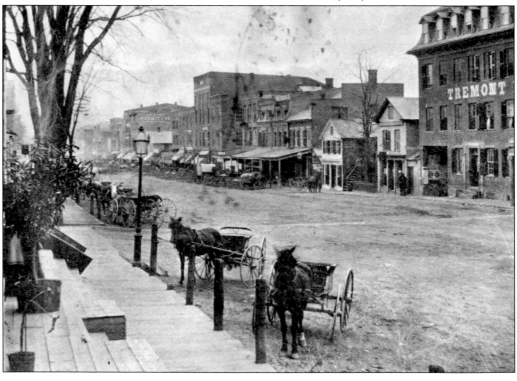

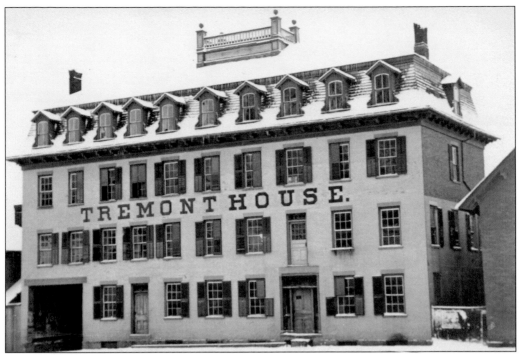

The Tremont House, seen here, was built in 1820 and closed its doors in 1881. Prior to the raid of October 19, 1864, Confederate army rebel Bennett Young and two of his soldiers stayed at the hotel. A drive-through access to the rear stables and courtyard appears at the left. Most of the horses stolen by the Confederates to escape to Canada came from E. P. Fuller's Livery Stable, which was located at the rear of the hotel. After the closure of the Tremont House, the Glen's Falls Shirt Company took over the building to produce white-collar products until the fire of 1895. Vermont Sentry Printing and the G. B. Bullett cabinet shop shared space in the building with the shirt company.

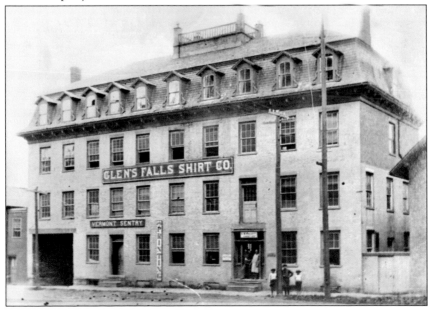

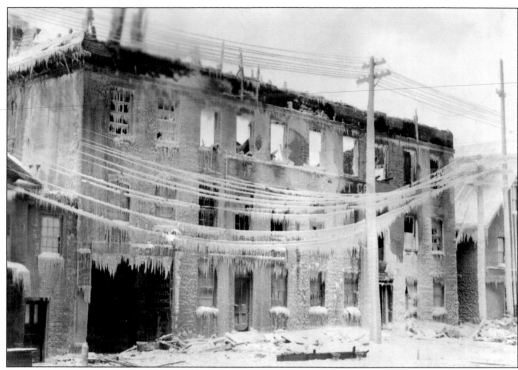

The fire of 1895 that started on the afternoon of May 19 destroyed the Tremont House. The fire originated in the W. B. Fonda paint shop and lumber sheds on the north side of Stebbins Street and, due to the strong south winds and low water pressure, carried hot cinders to Bostwick's lumberyards on Federal Street. The fire continued to consume business blocks, small wooden shanties, wood yards, private dwellings, and several barns along Kingman, Center, Pearl, Hoyt, and Main Streets. Mutual aid from Swanton and Burlington could not stop the quickly spreading fire. In 1896, a local architect built St. Albans City Hall on the site where the Tremont House once stood. This photograph of city hall around 1940 shows the stately building still in use today as a government and community center.

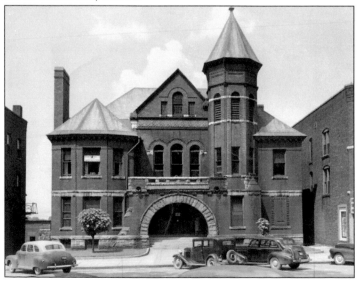

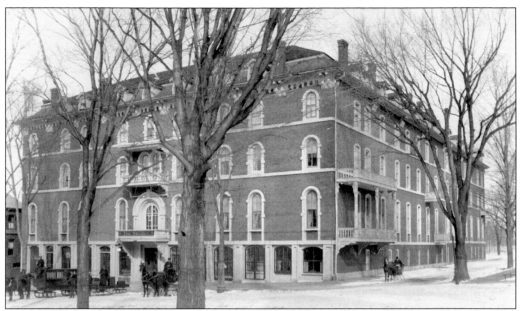

The Welden House, on the northwest corner of Bank Street and Maiden Lane, was Franklin County's only city-type hotel. Elinus J. Morrison, the only fatality of the St. Albans Raid, had come to St. Albans to work on its construction in 1864–1865. Its construction cost $200,000 for the 200 spacious rooms with quality furniture, carpets, and steam-heated radiators. Within the building were a post office, a barbershop, a billiard parlor, and a theater that could seat 250 people. The Welden, commanding an excellent view of Taylor Park, gained a wide reputation as a commercial hotel, a family and resort inn, and a premier dining establishment where a diner could order oysters five different ways as an appetizer. The photograph below shows the Welden's main desk and lobby. Note the beautiful counter, which like the other furniture, was black walnut or mahogany. Other appointments included a tobacco case and a mail cabinet.

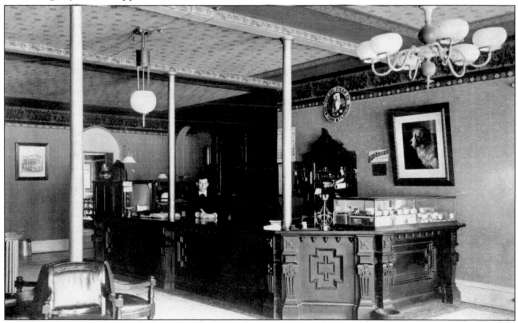

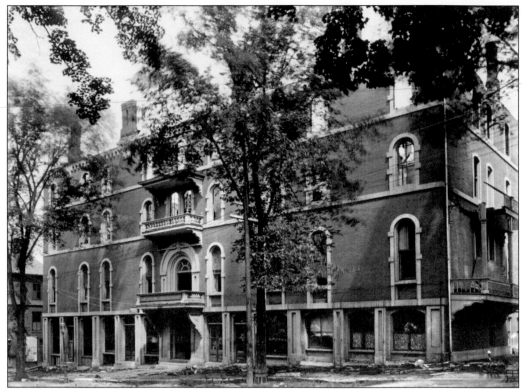

By 1880, St. Albans had a paid fire department of 50 men organized from three volunteer companies. In 1897, when the Welden House burned, the fire station was on Center Street, and its equipment was powered by horses. The well-known hotel was completely gutted, and the ruins were torn down. The vacant lot served as a baseball diamond for the local boys until a new hotel was built in 1910. Notice the debris along its sidewalk at the front of the Welden House and the damaged balconies on its Maiden Lane side. Much may be gleaned by studying the signs surrounding the former site of the Welden House. One may observe advertisements for entertainment at the opera house, moving pictures, and a number of products, such as Sloan's Liniment, Gorton's Codfish, and the *Boston Sunday Herald*.

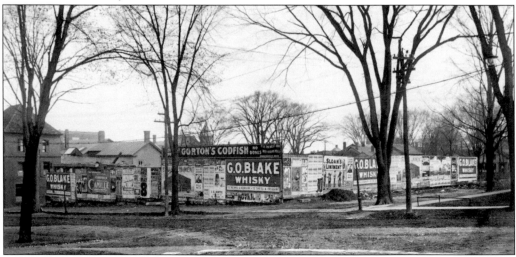

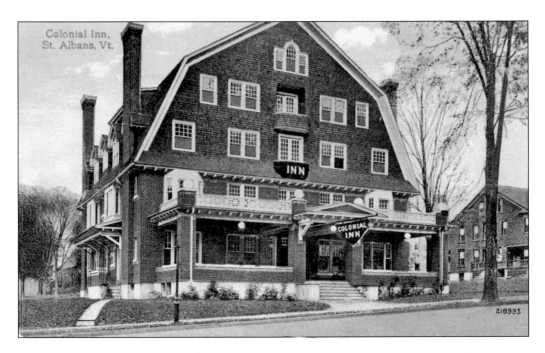

Colonial Inn,
St. Albans, Vt.

218993

In 1910, on the vacant lot where the Welden House had stood, Dr. G. C. Berkley erected a new hotel named the Colonial Inn. The Colonial Inn was purchased the following year, in 1911, by Henry S. Carlisle and was eventually renamed The Tavern. It too caught fire in February 1924, and people lined the street to watch as smoke and flames poured out of the building. By this time, the St. Albans Fire Department had moved to a new building on Kingman Street, which may have prevented the building from being destroyed. Note in the photograph below that the roof has been destroyed due to the fire. The building was left in salvageable condition to be reopened.

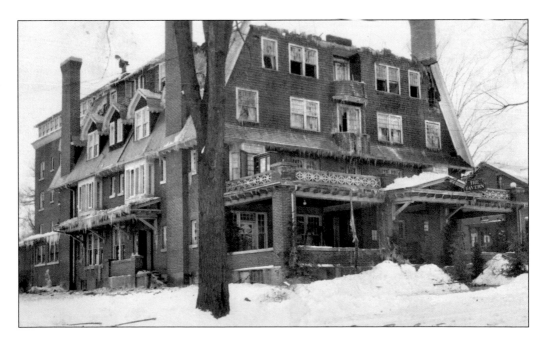

THE TAVERN

THE FIRE ESCAPE

is located at extreme end of corridor in rear of the building. Go past the elevator and stair case, and turn to right. Follow the Red Lights.

THE ELECTRIC LIGHTS

in this room are ON A METER. We want to give you all the light you need and have provided more than the usual number of fixtures. Kindly help us to continue this service, which is worth something to you, by TURNING OFF YOUR LIGHTS when not in use.

THE TELEPHONE

in this room is a long distance instrument. You can call any one, any where, any time.

THE DINING ROOM

is open from 6:00 to 9:00 a. m. 12:00 noon to 2:00 p. m. 6:00 to 8:00 p. m.
Sundays, 8:00 to 9:30 a. m. 12:30 p. m. to 2:30 p. m. 6:00 to 8:00 p. m.
A la carte service on the Roof Garden during the Summer months when Dining Room is closed.

PLEASE DO NOT

leave a window open in Winter where a radiator or the plumbing fixtures are likely to freeze from excessive cold.

THE TAVERN INVITES

a comparison of its facilities, conveniences, comforts, surroundings and service with those of other hotels.

OUR AIM.

The fame of THE TAVERN is builded upon its character as a hotel of quiet refinement and elegance. Practically every part of it is fashioned upon new ideas in hotel development and construction. THE TAVERN is differently different from other hotels. Contentment is spelled in every nooky corner of a house beautiful,—Colonial in design, homelike in appointments, Blue-booky in service. The rates are distinctly normal, moderate and always to the satisfaction of the guest. It is completely equipped with rooms en suite, baths, long distance telephones, roof garden, elevator service, fire places, grill, private dining rooms, Japanese nookery, broad piazzas and many dainty cozies that please and delight the guest. The management aims to make it a model hostelry where the cuisine is distinctive, the service enjoyable and the welcome contagious.

We want to make THE TAVERN what you want it to be,—a good hotel and a good home. Your ideas suggesting improvements will be welcomed and carefully considered. It is your house; use it as you would your own.

THE TAVERN.

With memories of the elegance of the Welden House still keen, the accoutrements of the Colonial Inn and The Tavern required special attention. This individual room bill touts the qualities of The Tavern and includes information on hotel services. Note the words "refinement" and "elegance." "Blue-booky" indicates that service is premier and that hotel employees were well trained in service to the clientele. The Tavern offered rooms en-suite, baths, elevator service, fireplaces in addition to steam-heat radiators, and public and private dining rooms. Long distance telephone and electric light services were available. Electricity came to St. Albans around 1890, and the Franklin County Telephone Company's service became available here in about 1911. The Roof Garden was open during the summer, where à la carte service was available to patrons. Notice that guest instructions in the event of fire are listed first on this bill.

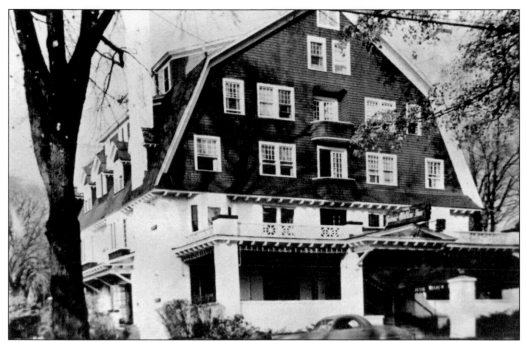

The Tavern was bought in 1941 by E. B. Gordon of Associated Hotels of New Haven, Connecticut, and the name changed to the Jesse Welden Inn, evoking the name of the Welden House, the first grand hotel on this site. The Jesse Welden, as it became known, continued to serve the area as a premier hotel also known for its excellent restaurant. There were lively dances held on the upper level and in the rooftop garden during the summer. The building was destroyed by fire on January 31, 1948, in 16-degree below zero weather. The United Press reported that some 60 people were forced to evacuate. Fire chief Richard H. Sweeney reported only five firemen on duty, and the handful of men was unable to lift the heavy ladders. By the time help arrived from Swanton and Burlington, the whole building was ablaze.

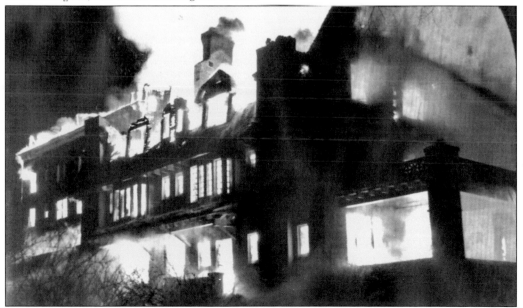

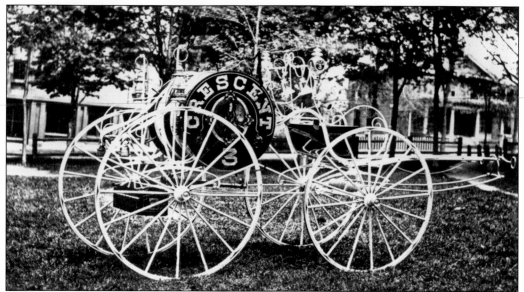

The two photographs on this page show an evolution of firefighting in St. Albans from the 19th century to the early 20th century. The Crescent 3 fire engine of 1875, shown above in Taylor Park, was the first in St. Albans. Modeled on a typical four-wheeled drawn carriage, it was fitted with a hose and wheel, along with an assortment of ladders. By 1880, the first paid fire department of 50 men was organized from three volunteer fire companies with the fire station on Center Street. In 1900, the fire department moved into its new building on Kingman Street. It had stalls for three horses, as well as the hose carts and equipment. This fire station is now part of Peoples Trust Company. To the right of the station can be seen the alley and building that currently contain the Peoples Trust drive-up banking window.

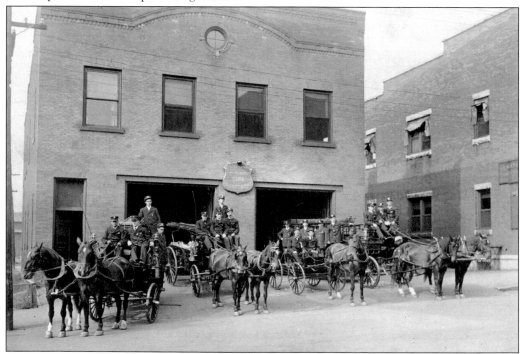

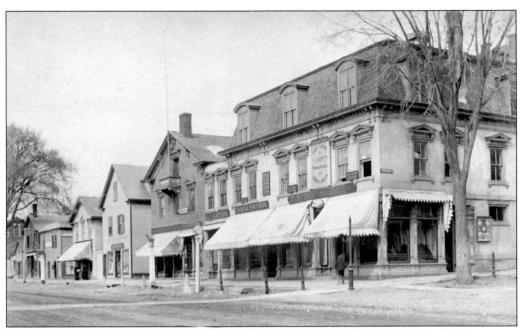

Sometime after 1875, this photograph shows the F. F. Twitchell and Company store on the corner of Bank and Main Streets, offering "Dry Goods and Carpets, Popular Goods at Lowest Prices." Jeff's Maine Seafood Restaurant now occupies this location. Next to Twitchell's is the jewelry store of Charles Wyman, who offered clocks, gold- and silver-plated goods, spectacles, glasses, and table and pocket cutlery. Many shops' signs or posts showed an image depicting their type of business, such as the clock in front of the jewelry shop and the mortar and pestle on the next post. Note the hitching posts in front of Twitchell's. Below, looking north from the corner of Main and Bank Streets, is the clock from the Twitchell's store next to the wooden walkway. The Brainerd Drug Store, as well as Twitchell's, survived the fire.

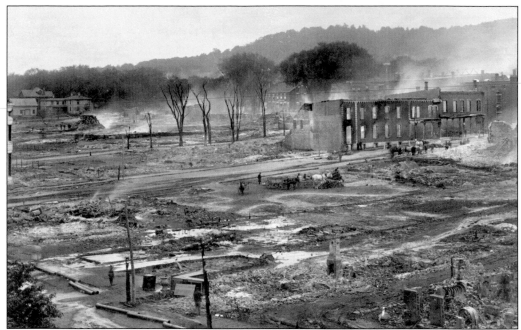

Some of the devastation of the fire of 1895 is shown here looking north from the vicinity of the general office building of the Central Vermont Railroad. The white building seen at the left was the federal building, which also housed the post office. This building was gutted and rebuilt with a different roofline. The shell of the building to its right was the *St. Albans Messenger* office.

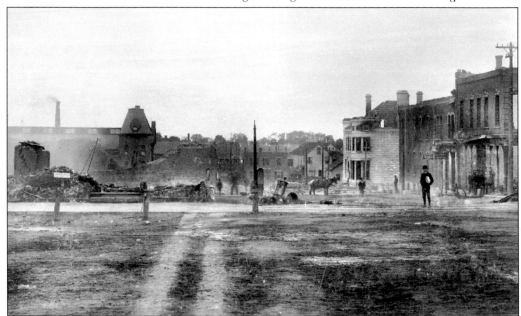

This photograph also depicts the devastation of the fire of 1895 looking west from Taylor Park at the corner of Main and Kingman Streets. At the right, notice the former Messenger building on the site of the later American Legion and now a parking lot for the Peoples Trust Company. Buildings remain along Federal Street in the background, including the tower of the Central Vermont Railroad engineering department that was razed around 1963.

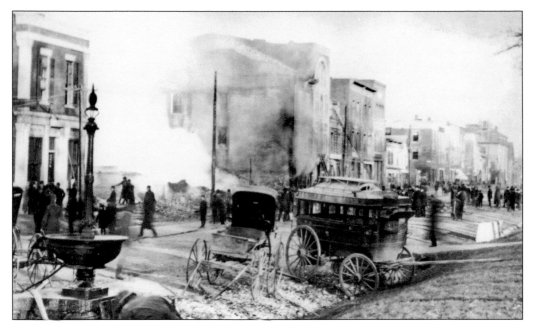

This photograph of the fire of 1891 shows the west side of Main Street looking north. Many of the townspeople are milling about, no doubt overwhelmed and in shock at the devastation before them. Others appear to be raking through the rubble in the hope of finding some personal belongings. To the left is an ornate trough, and a stagecoach has been pushed away from the fire towards the grass of Taylor Park.

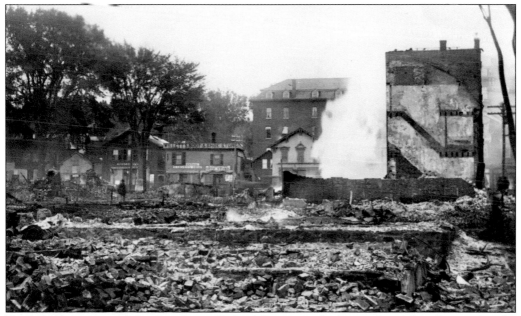

From the former site of the foundry on Federal Street, one looks north to Main Street after the fire of 1895. Beyond the rubble to the left between the trees was Miss Beattie's Millinery Shop, in front of which Elinus Morrison was mortally wounded during the St. Albans Raid. In the background, center right, the upper floors of the Welden House are visible. It would succumb to fire in 1897.

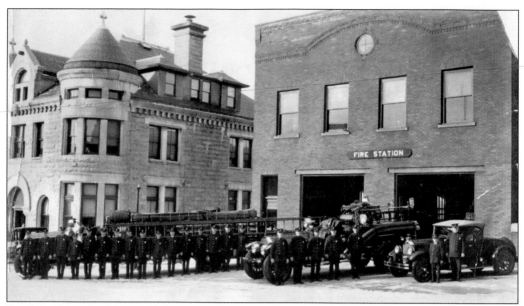

By the 1920s, the horses of the St. Albans Fire Department were gone and replaced by motor vehicles. In this photograph, the 21 firefighters are standing at attention in their snappy dress uniforms, including the fire chief and the yet-to-be-chief. The cabless ladder and pumper trucks are at attention as well, with their shiny paint and polished chrome and brass. New to the department is the speedy-looking car of the fire chief, equipped with a serious siren. The building to the left, formerly a Vermont district court, is currently property of the Peoples Trust Company.

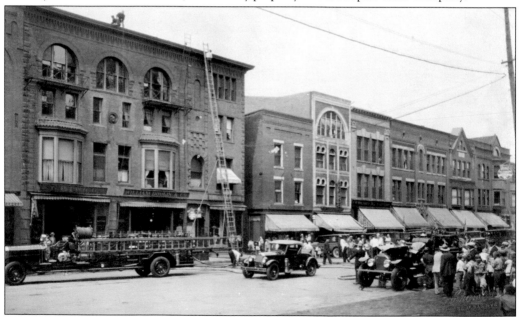

A well-attended demonstration of firefighting activities fills this 1929 photograph. The ladder truck, pumper truck, and the chief's roadster are still shiny, and the firemen are busily engaged with ropes, ladders, and hoses simulating rescue and equipment supply activities. Residents of the apartments above the Doolin store seem to be going about their business, while a few in the Woolworth building show casual interest.

Four

TOWNSPEOPLE

William D. Chandler's photographs constitute the largest group of pictures in this book. He was born in Berlin, Vermont, in 1864 but spent most of his 63-year photography career in St. Albans. Chandler also advocated for paved streets and was instrumental in developing Route 7 from the Canadian border to Norwalk, Connecticut. Pictured here is the actual sign advertising his studio on the corner of Main and Kingman Streets.

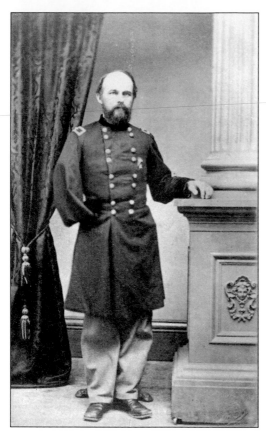

Gen. George Jerrison Stannard was born on October 20, 1820, in Georgia, Vermont. He later lived in St. Albans, where he initially was hired as a clerk for the St. Albans Foundry Company in 1845. He aided in the organization of the St. Albans Ransom Guards in 1856 and was said to be the first to answer the call for volunteers in 1861. His 2nd Vermont Brigade stopped Pickett's charge on July 3, 1863, at Gettysburg, the turning point of the war. He lost his arm in 1864, caused by wounds received after capturing Fort Harrison.

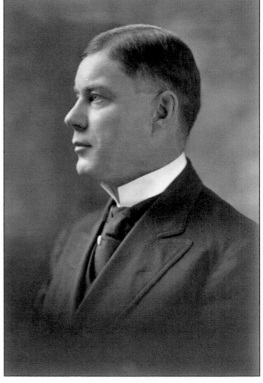

Elbert Brigham, 1877–1962, is shown at the right. Brigham graduated from St. Albans High School in 1898 and established a herd that was considered the top-producing Jersey herd in the country. At the time of the herd's dispersal from his Brigham Road farm in 1962, buyers came from all over North and South America. Brigham served in many civic and business capacities, including representative to Congress from 1924 until 1930.

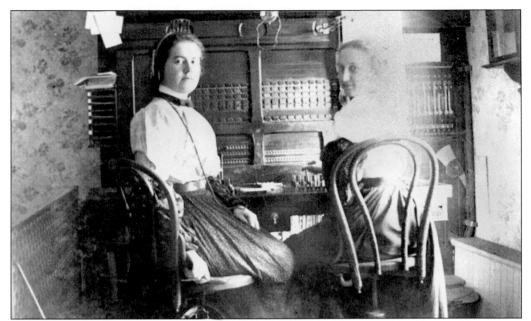

The first telephone exchange in St. Albans arrived in the early 1890s. Amidst plugs, wires, headphones, and cards sit Miss Conner and Miss Robertson, the two women responsible for making the connections for the St. Albans Telephone Company in 1895. While customers may have been few, matching the right plug to the right outlet was critical, so the young women's memories had to be precise to avoid delays and complaints.

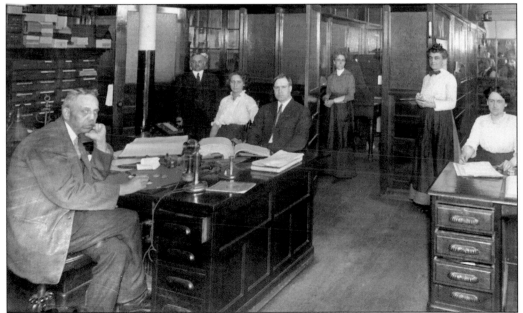

Part of the St. Albans Messenger Company of 1900–1912 is shown here partitioned off into various workstations. Desks, drawers, boxes, and panels create a sense of efficiency, as do the seven employees in the room. Those identified are Arthur B. L'Ecuyer, seated at the left; Lena Hamilton, seated at the right; and Kate Cummings, standing behind her. Also pictured behind Lena Hamilton and beyond the windowed door is a group of people whose business could be urgent.

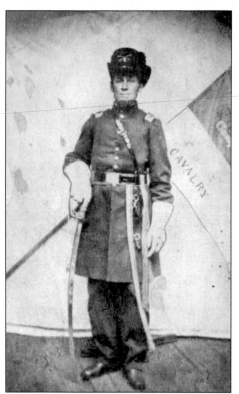

Capt. George P. Conger (1815–1895) served in the Civil War with the 1st Vermont Cavalry organized by the federal government, partly because of the fame of St. Albans's Morgan horses. They were led by famous men: Sheridan, Custer, and William Wells, a Vermonter who became a major general. Captain Conger was among the men who pursued the Confederates after the St. Albans Raid in October 1864.

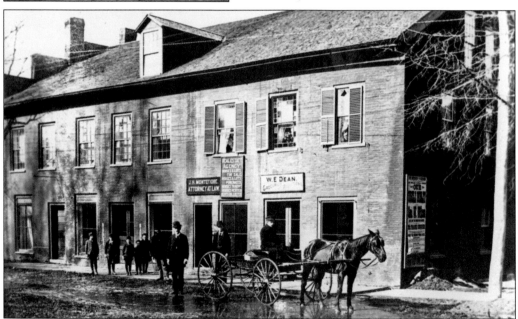

Joseph H. Montefiore was a printer, lawyer, and journalist in Vermont, the son of Joshua Montefiore, thought to be the first person of Jewish descent to have migrated to St. Albans. Joseph Montefiore served with the 7th Vermont Regiment during the Civil War, soon after he had enlisted in Fairfield on February 22, 1865. He was admitted to the Vermont Bar in 1869, and his office, seen here, was located on North Main Street.

The Smith family has contributed so much to St. Albans over the years. From their arrival here in 1800, they were farmers, lawyers, railroad builders, entrepreneurs, politicians, writers, and philanthropists. John Gregory Smith (1818–1891) was a graduate of the University of Vermont and Yale Law School. He served in the Vermont legislature as a representative and senator and finally as governor (1863–1864). He and his father-in-law, Lawrence Brainerd, organized the Vermont Republican Party. Ann Eliza Smith (nee Brainerd) received a classical education at home and was also proficient in household skills. She wrote three historical novels, poetry, and essays on theology and philosophy, which were published. She and J. Gregory lived in The Towers. They had five children. Their younger son, Edward Curtis Smith, was active in state politics and was governor of Vermont (1898–1900).

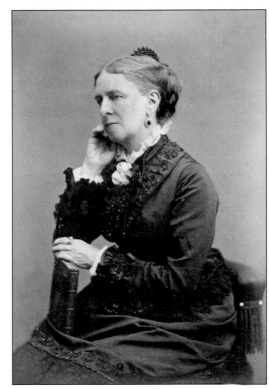

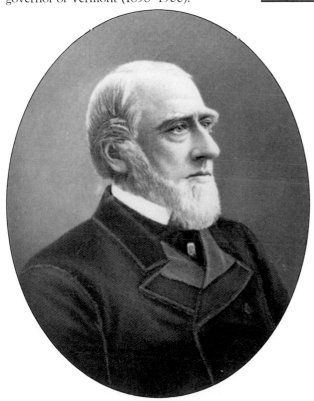

Arthur "Scott" Bailey (1877–1949) was born in St. Albans, where he graduated from the academy on Church Street in 1896 and then attended the University of Vermont for two years. In 1899, he transferred to Harvard, graduating in 1902. He was a New York publisher from 1904 to 1911 and then began a very successful career writing children's books. His works centered on the animal, bird, and insect worlds, and his animals always had names like Billy Woodchuck, Cuffy Bear, and Dickie Deer Mouse. Bailey never wrote down for his readers but instead was known to use vocabulary beyond the average juvenile reader. Arthur Bailey is buried in St. Albans.

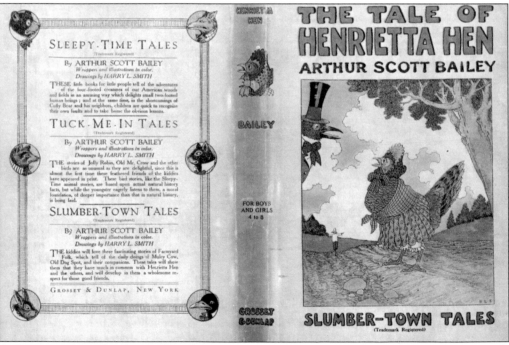

A Grosset and Dunlap dust jacket of Scott Bailey's *Slumber-Town Tales* would make any juvenile curious. The Harry L. Smith drawings of Henrietta Hen jabbering at her top-hatted, bow-tied crow friend beg the youngster to turn the page. Whatever the two are talking about, it sure looks urgent. Is Henrietta worried or irritated? Is crow here to help? This book must be opened.

Frances Frost (1905–1959) spent an active childhood at 10 Stebbins Street, close to the railroad where her father was employed. She began writing early in life and continued at St. Albans High School, Middlebury College, and the University of Vermont. In 1929, Yale selected her as its Young Poet of the Year and published *Hemlock Wall*, a volume of poetry. She authored several more volumes of poetry and numerous novels.

Allene Corliss was born in 1899 to a prominent Fairfield family and married St. Albans businessman Bruce Corliss. After several years of marriage and three children, she began to pursue her writing career. In 1938, her novel *I Met My Love Again* was made into a romantic drama starring Joan Bennett and Henry Fonda. She was written about in several nationwide magazines, including *Woman's Home Companion*. Corliss died in 1979 and is buried in the Bradley Cemetery in Fairfield.

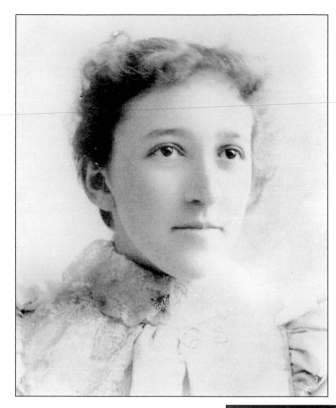

Grace Willem Sherwood (1878–1948), the daughter of Dr. Ralph W. Sherwood, wanted to follow in her father's footsteps. She graduated from St. Albans High School in 1897 and from the Female Medical College in Philadelphia in 1904. Dr. Grace, as she was known, began practicing in St. Albans in 1907, where she owned and operated a sanitarium providing for the terminally ill.

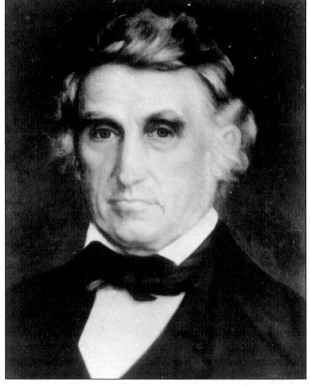

Young William Beaumont (1785–1853) was intrigued with all things medical from an early age. He bought an apprenticeship with Dr. Benjamin Chandler, and after two years of working with him, Beaumont received his license to practice in 1812. While an army surgeon, he was able to directly observe gastric digestion. His published findings became a guidebook for medical students.

Louella Kittell (1897–2001) graduated from St. Albans High School in 1916, Swanton Teacher's Training School in 1917, and the University of Vermont in 1934 and 1959. After nine years of teaching elsewhere, she spent the next 41 years teaching in St. Albans. She retired in 1967 and continued to operate a bed-and-breakfast from her home on North Main Street.

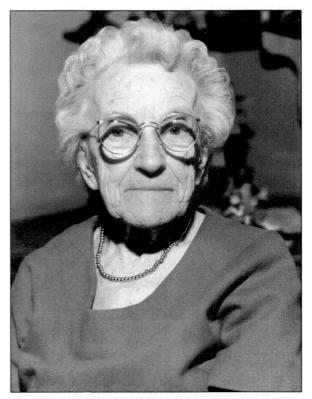

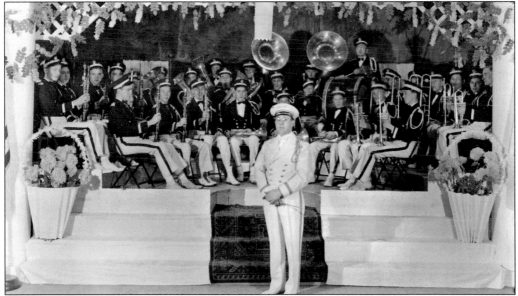

Sterling Weed was born July 20, 1901, and after beginning his directing in 1928, he would eventually become the oldest living orchestra conductor in the United States, living to be over 100. He was a teacher at Bellows Free Academy for 40 years and was bandleader of Weed's Imperial Orchestra from 1932 onward. On June 8, 2001, the Vermont Arts Council awarded him a Lifetime Achievement Arts Award. He died on September 11, 2005, at his home on Stebbins Street in St. Albans.

The murder of the young schoolteacher, Marietta Ball, on a high wooded hill east of St. Albans continues to echo. On Friday afternoon, July 24, 1874, Ball left her school afoot for her usual weekend stay at the Foster Page family home. Part of her walk passed through a stretch of broken timber, where she was assaulted and killed. The initial suspect was Frank Harris, a black man, who found Ball's body. He was arrested, jailed, and his house was searched. For lack of evidence, Harris was released, and the investigation soon ceased. In October 1875, the Ball case resurfaced with the arrest of Joseph LaPage, a middle-aged Frenchman, for the murder of Josephine Langmaid in Suncook, New Hampshire. LaPage, who also used the aliases Joseph Pagette and Joseph LaPaize, had been released as a suspect in the Ball case for lack of evidence. Not as fortunate in the Langmaid case, LaPage went to the gallows on March 15, 1878. The only similarity between the Ball and Langmaid murders was that both women's bodies had been washed. It has never been proved who killed Marietta Ball.

Five

ST. ALBANS BAY

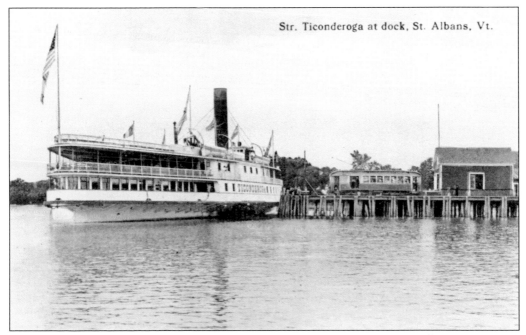

Str. Ticonderoga at dock, St. Albans, Vt.

The importance of Lake Champlain in the shaping and growth of St. Albans cannot be overemphasized. The lake offered an unhindered, swift highway for commerce during much of the year. A permanent dock was built at St. Albans Bay, briefly called Port Washington, around 1810 at approximately the site of the present pier. This photograph shows the *Ticonderoga* at the bay dock where passengers could take the trolley into St. Albans.

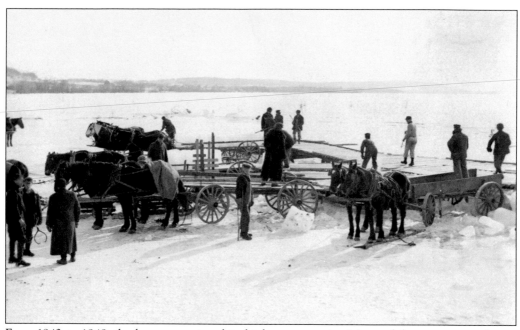

From 1843 to 1849, the bay area enjoyed its highest prosperity. Many of the county merchants had become wealthy, and their large stocks furnished business for the transportation line of boats. Commodore Oscar A. Burton established a bank, and the bay boasted a church and a hotel, among other businesses. The lake also provided areas for recreation, and private docks were numerous along its shores. Ice was harvested at the bay as shown in these photographs. The top picture shows several wagons waiting to load, while the bottom photograph shows the staging from which the ice blocks were loaded. Later the ice was delivered door to door to homes where a signal card had been placed in the window to indicate whether 25, 50, 75, or 100 pounds of ice were needed.

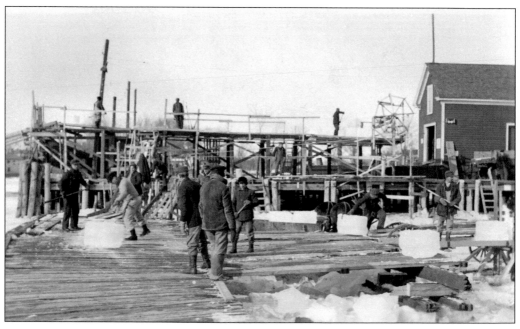

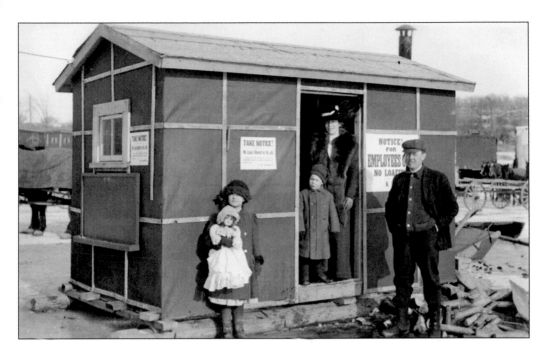

In St. Albans, ice was delivered locally into the late 1940s. Harvesting ice provided work for many people. In 1878, there were 11,000 men employed just in New England. This was a great winter job for farmers and farmhands, as well as itinerant laborers. The photograph below shows a load of ice blocks headed up Fairfield Street for delivery to the icehouse. The iceman was a popular person on a hot, summer day. Children gathered around hoping to get a few chips as the iceman, wearing his leather smock, cut the big chunks into the desired size. The photograph above shows Viola and John Sanborn at the doorway of an ice shed at St. Albans Bay.

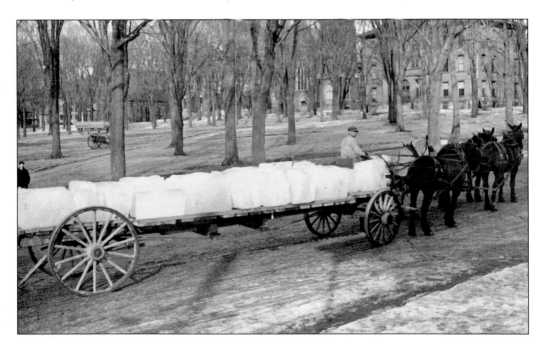

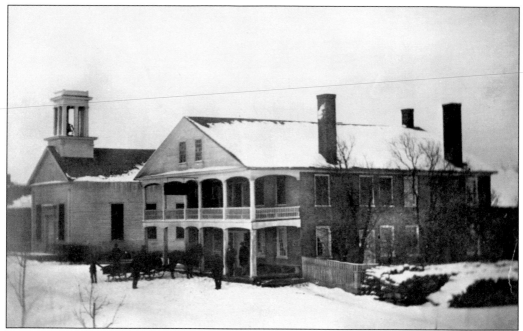

In this scene, the brick building to the right is the A. Brooks Hotel, which was located on the south side of Lake Road near the present Bayside Pavilion, and was also possibly used as a store. To the left of the hotel stood the old wooden Methodist church, which burned in 1874. The present Methodist church was rebuilt across the street that same year.

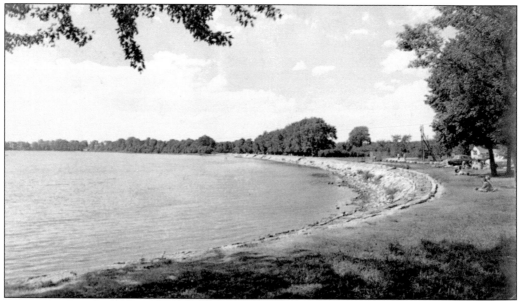

St. Albans Town bought the 30-acre Mosher Marsh in 1934 for $500 and presented it to the Vermont Department of Forestry for development of the beach for recreational purposes. The State Forest Park was dedicated in 1939, and its construction was a major effort by the Civilian Conservation Corps, relocating State Highway 36. Rocks for the construction of the seawall and bathhouse were quarried at two St. Albans town sites near Kellogg and Lake Roads. St. Albans Town purchased the park from the state and maintains it for recreational purposes.

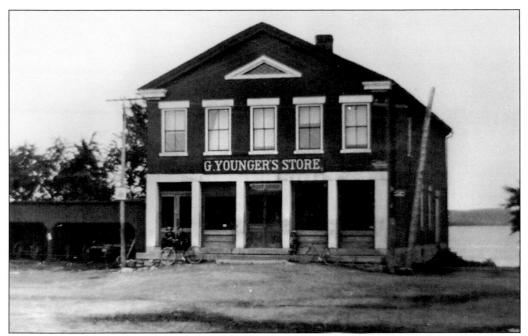

George Younger's Store, around 1920, sits on property deeded to George Younger by A. O. Burton and I. S. Bostwick in the mid-1800s. It is situated at the foot of Lake Road, just south of the St. Albans Bay dock, then known as Burton's Dock. This building, originally a theater, has served a variety of capacities: grocery store, post office, antique and consignment shop, and as a residence.

During a renovation of his sports shop at 139 Lake Street, Jules "Chic" Chicoine uncovered the poster shown in this photograph. It is believed that the theater mentioned may have been at Younger's Store at the foot of Lake Road at St. Albans Bay. Notice that refined comedy and vaudeville are advertised and that, for 25¢ from St. Albans and 35¢ from Swanton, one could arrive on the electric railway.

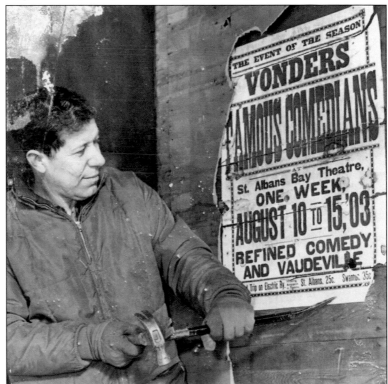

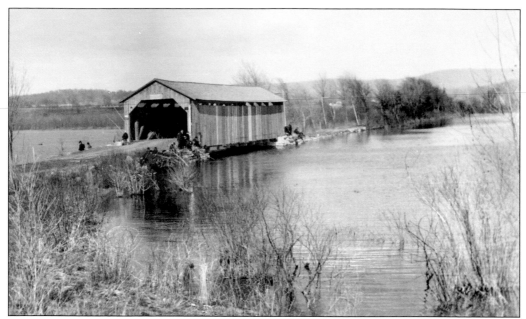

This picture shows why the Black bridge was called fishing bridge. One can imagine these men spending a leisurely Sunday afternoon with rod in hand and socializing with friends. The water was at its highest at this time of year, in early spring, and the men appear bundled up to keep warm. The bridge, located at the north end of the bay just before the Hathaway Point Road, was replaced with a metal bridge in 1928.

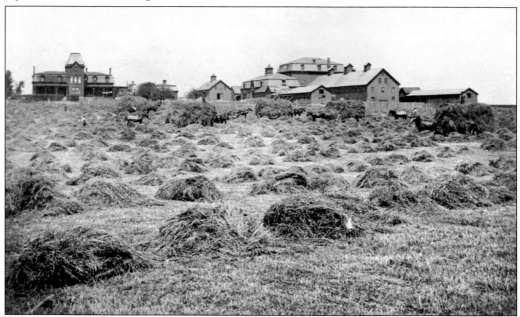

Over the years, the Smith family homes and properties dominated St. Albans real estate with such residences as The Towers, Elmhurst, and Seven Acres. The Point Farm shown in this scene was located just beyond the turn to Hathaway Point at St. Albans Bay on what is currently known as the Maquam Shore Road. Note that hay was harvested manually at this time. None of these buildings exist today.

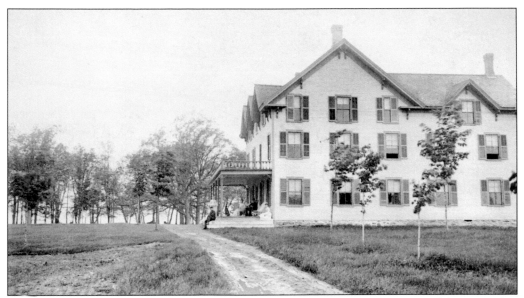

Rocky Point, today known as Hathaway Point, was descriptive of the character of the point that juts into Lake Champlain on the southwest side of St. Albans Bay. This building, around the late 1800s, was originally the Rocky Point Hotel and then became Hotel Champlain. It became a country club in the early 1900s and eventually Kamp Kill Kare, a summer camp for boys. Today it is the base for the Kill Kare State Park.

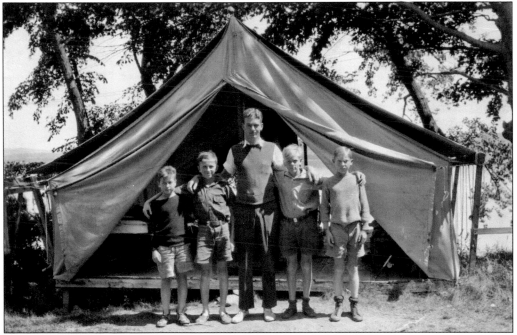

Located on the southern end of Hathaway Point, Kamp Kill Kare, a camp for young boys, was established in 1906 and operated until 1966. Pictured here are, from left to right, Teddy Kehoe, Whitney Cushing, Foster Orton (counselor), Johnny Willson, and Teddy Scott. Many activities were offered, such as tennis, track, swimming, boating, sailing, nature study, riflery, crafts, and baseball. For parents who desired their boys to study along with their play, tutors were available.

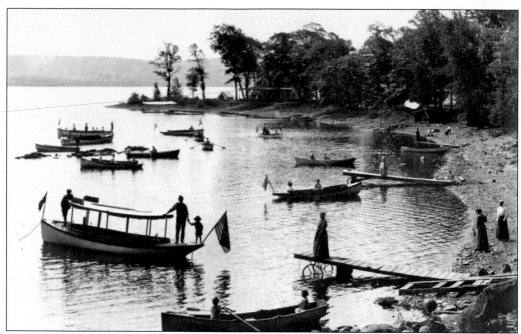

This misty morning on Hathaway's Point in the early 1900s shows the summer campers at their active best. A variety of boats and boaters—young and old—heading out, in, or just idling are engaged in pure leisurely enjoyment. Standing on the shore or deck are overseers, safety supervisors, and cheerleaders of these happy campers beginning their day.

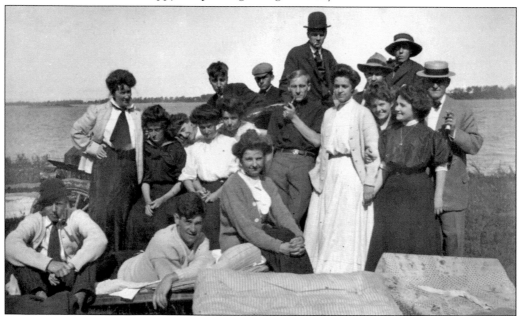

Getting a group of adults and youngsters together for a photograph shoot seems to be easy for the campers here at the Royce Cottage about 1900. Pictured in this photograph are "Bug" Royce (top left) George Jones (at the right and wearing the straw boater), and Arthur Twigg (lying on the mattress). Others in the photograph may be Edward Alexander, June Mitchell, Lois Fonda, Leo Willson, Haroldine Twigg, and Christine Stranahan.

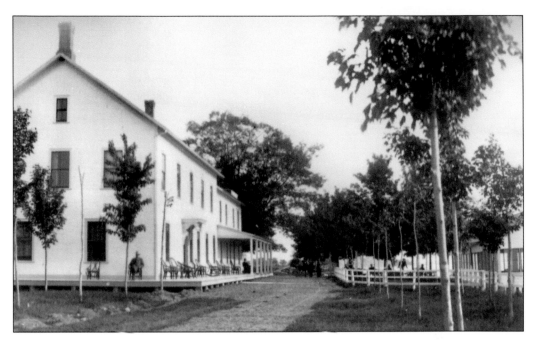

The shores of Lake Champlain were home to several hotels and summer cottages. These two images show the Lake View House and its shoreline looking west. The hotel was popular with guests who enjoyed fishing because of its proximity to Woods Island Bar, a famous bass grounds. Several guides operated out of this area. They were called rowers for obvious reasons. This site also served as headquarters for the Kamp Kill Kare tutoring camp in the early to mid-1900s. Also note in the photograph below that ladies were among those enjoying the canoes. Lake View House was owned by Wilson Samson, manager of City Feed and Lumber. The land remains today in the Samson family.

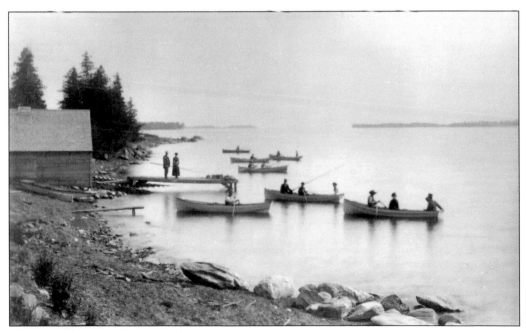

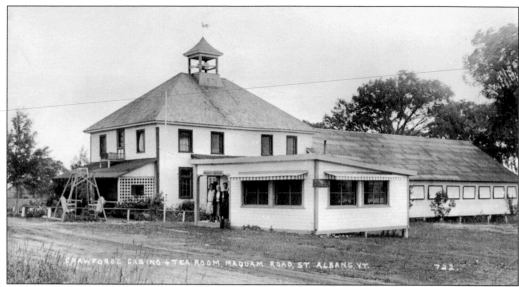

After fishing, the most popular recreational use of the shores of the St. Albans Bay area was probably picnicking and group cookouts, including fish fries and chowder parties enjoyed by locals and people from the cities in search of vacation activities. Tenting became popular in the late 1800s for families and organizations. During the 1880s, there was a Methodist camp meeting tent on Shanty Point, which was rented by families for a period of time when it was not in use for religious purposes. Crawford's Casino on the Maquam Shore Road in the above photograph also offered a tearoom in addition to dances. Below, the Corliss Cottage at St. Albans Bay is host to the St. Albans Businessmen Professional Association for a lakeside gathering in the early 1900s. Notice what appears to be an exterior water heater on the upper left of the cottage.

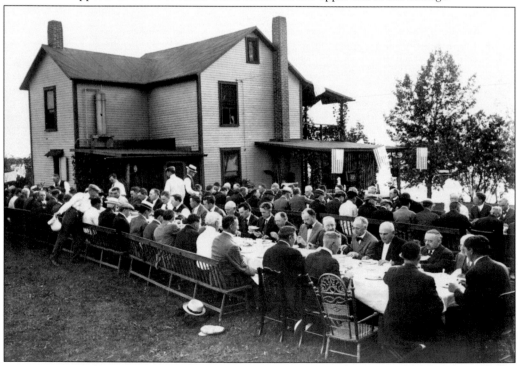

Six

SCHOOLS AND SPORTS

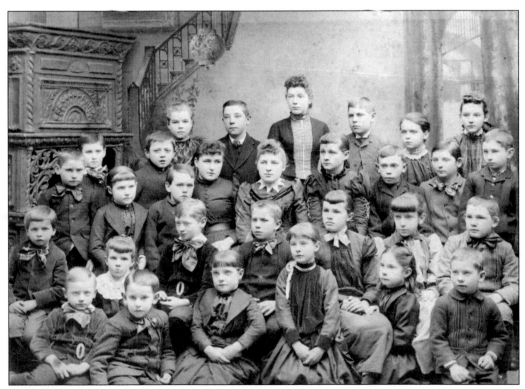

Education has been vital to the people of St. Albans. Neighborhood elementary schools kept the children within a comfortable distance from home. Such was not always the case for the one-room schools. Here are students at the Tullar School at the corner of Lower Newton and Kellogg Roads in 1886. Ella Collins Dunsmore is at the left of the fourth row, and her brother Harvey Collins is pictured in the second row in front of the teacher.

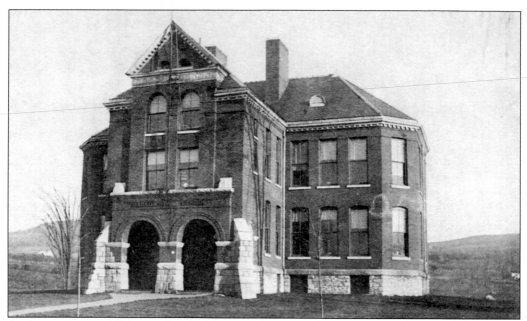

At the corner of Barlow Street and Upper Welden, Barlow Street School stands in all its newborn nakedness in 1895, the year of its birth. Its magnificent brick and stone complement its arches, angles, and chimneys. Built to accommodate a growing population, the school housed grades one through four. Today Barlow Street School is the happy home of the St. Albans Recreation Department, and its surrounding grounds provide ample athletic activities.

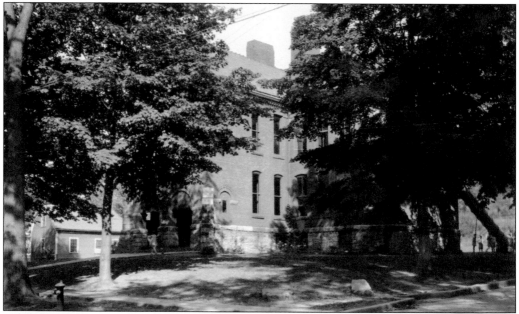

The Messenger Street School, also built in 1895, stands proudly on the corner of Messenger and Upper Newton Streets as it appeared in the 1920s. Like its sister school, it accommodated students in grades one through four. For fire safety, the fire hydrant on the lawn and fire escape tube were in place. The style of pupil dress can also be seen near the tube. Currently the school is a very active seniors' center.

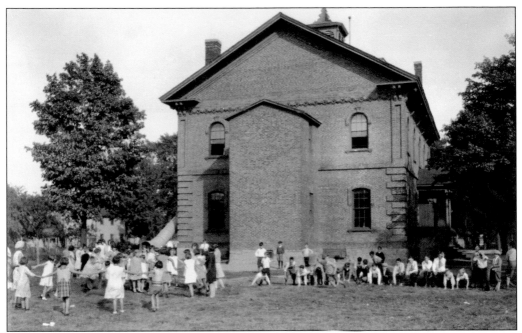

The Elm Street School taught students from first through fourth grades. The school was built in 1880 and is located behind Holy Angels Catholic Church. Here children enjoy a much-earned recess: girls playing the traditional ring-around-the-rosy and the boys taking turns practicing their pitching skills. At the time, the school was the city's second oldest school. It is now senior housing.

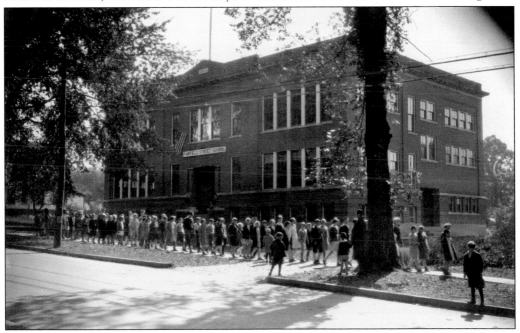

Fairfield Street School, built in 1911, became home to grades five and six, which previously met at the Church Street Academy, along with grades seven and eight and the high school. Fairfield Street School closed when grades one through eight moved to the new St. Albans City Elementary School on Bellows Street in 1970. Today this well-maintained building is used for housing.

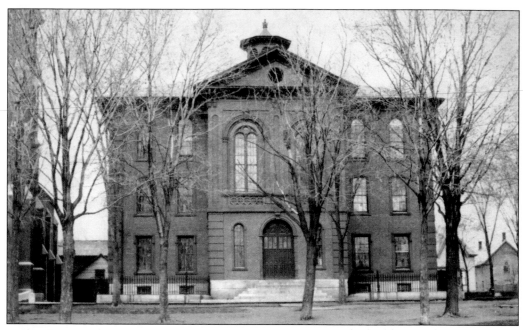

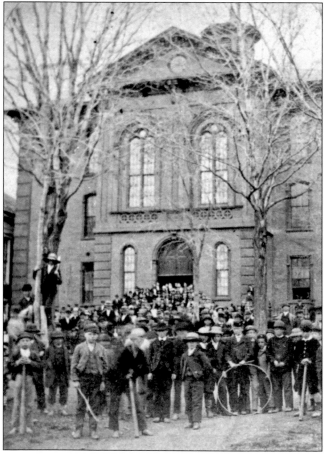

The building in these photographs has a long and rich history. In 1799, the lot on which the St. Albans Historical Museum currently stands was selected for the Franklin County Grammar School. Prior to this time, there were district schools located on Foundry Street (now Federal Street) and on Messenger Street, the only free schools in the village. The first building was erected in 1801 and served until 1828, when a larger school building was erected. In 1861, a new academy building replaced the former school, and in September 1861, the coed Franklin County Grammar School opened. St. Albans High School, established in the mid-1860s, also convened here. Grades one through four eventually moved to Barlow and Messenger Street schools, grades five and six moved to Fairfield Street School in 1911, and the high school to Bellows Free Academy in 1930, leaving grades seven and eight at Church Street School until its closing in 1969.

Hiram Bellows (1798–1876), a self-educated man, willed 250 shares of New York Central and Hudson River Railroad stock to St. Albans to build a free academy. The stocks were sold for $270,000 in 1929, and Bellows Free Academy was erected on Main Street on the site of Bellows's home and the neighboring house seen in the above photograph. Bellows believed that no student should be deprived of an education for lack of necessary funds. At the dedication ceremony on May 28, 1930, architect W. H. McLean said, "No other city in New England can boast of a school more modern and complete." The school was equipped with science labs, a domestic science department, a gymnasium complete with shower and dressing rooms, and an auditorium seating 715 people. Bellows Free Academy has added to its campus over the years and remains the only high school for St. Albans City and Town.

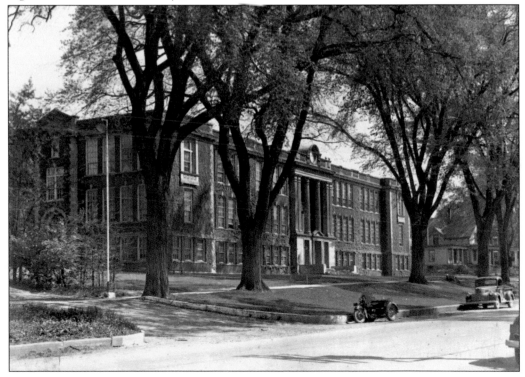

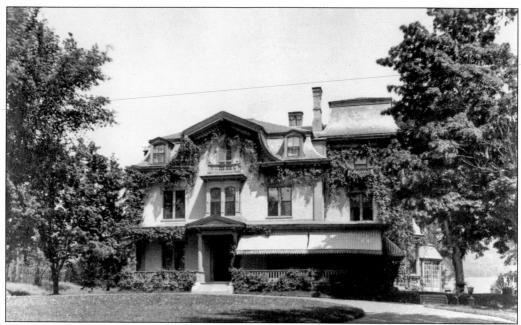

Elmhurst was built in the mid-19th century by Worthington C. Smith of St. Albans and gives the current Smith Street its name. For many years, this mansion was a home of princely hospitality. Together with its adjoining estate, it became the showplace of northern Vermont. Visitors came from afar to admire the mansion, the beauty of the grounds, the spacious greenhouses and conservatory, sturdy stables, and model stock farm. An 1843 graduate of the University of Vermont, Smith was generally known as a railroad man and state politician.

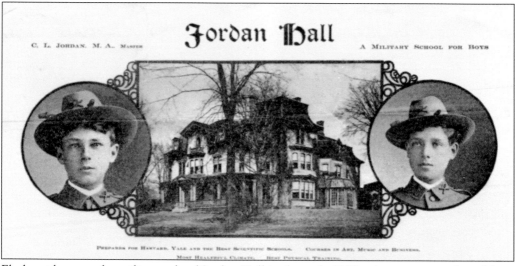

Elmhurst became the military school Jordan Hall in the early 1900s when it was purchased from the heirs of W. C. Smith by Prof. C. L. Jordan. A former professor of English and economics at Norwich University, Jordan made Jordan Hall a military school for boys to the age of 15. He believed that military discipline enhanced deportment, physical development, willpower, self-control, and leadership. The school maintained a high spiritual atmosphere and required regular church attendance. The teachers were carefully selected for their personal character and mental fitness.

Fr. Louis J. Derochers was very involved in developing Holy Angels School. His innate sense of adolescent development led him to divide the classes for maximum student progress in grades 1 through 10. In 1918, he added a two-year commercial course, which was considered to prepare the most excellent typists, stenographers, and accountants for many years. Such businesses as the Central Vermont Railroad were eager to hire graduates of the commercial course.

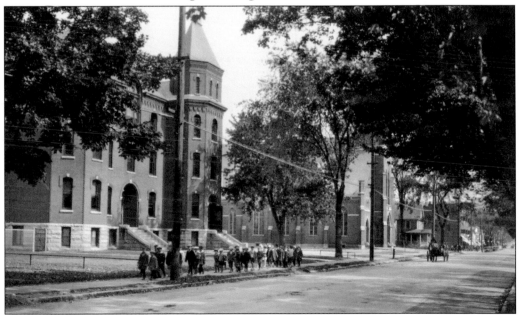

Holy Angels Church is located on Lake Street and was built primarily for French-speaking parishioners. In 1872, the ground was purchased, and a basement church was used for several years until the present church was completed in 1886. To the left of the church, the children are walking in front of the combined school/convent built in 1899. The original school was located on Elm and Pearl Streets, decidedly too far from the church.

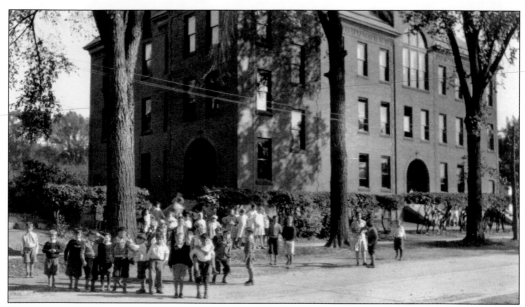

St. Mary's School was erected in 1901 as a parochial school covering grades 1 through 10 under the direction of the Sisters of Notre Dame. Grades 11 and 12 were added in 1909. The building was remodeled, and by 1933, it served as the high school with lower grades overflowing into the little red schoolhouse beside the church off Lincoln Avenue. In 1966, students moved to Central Catholic High School, presently the St. Albans Town Educational Center. The original building was eventually demolished.

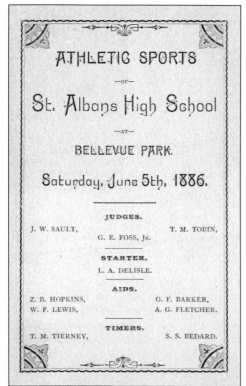

The front page of this athletic program from 1886 for the St. Albans High School suggests that sports and personal athletic development were an important part of high school life. This contest included such events as "kicking foot ball," "standing broad jump," and "standing hop, skip and jump." The event also featured a "three-legged race—100 yards," a "tug-of-war," and a "match game of baseball" between the "Swantons and the Academics."

St. Albans High School established its first football team in 1891, no doubt realizing strength of body went along with strength of mind, and encouraged team spirit to work for a common goal. Pictured here are, from left to right, (first row) A. W. Daly, Thomas Kennedy, George Hubbell, and James Gilson; (second row) William Buck; (third row) A. W. Coote, Royal Kimball, H. Montifiore, Daniel Woods, Oscar Woods, A. Beeman, and A. Morton.

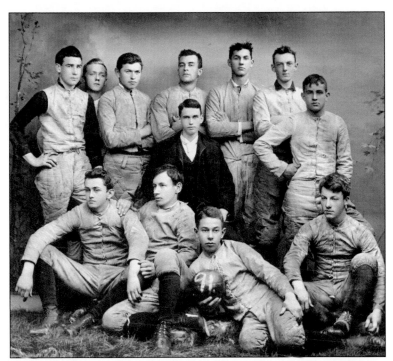

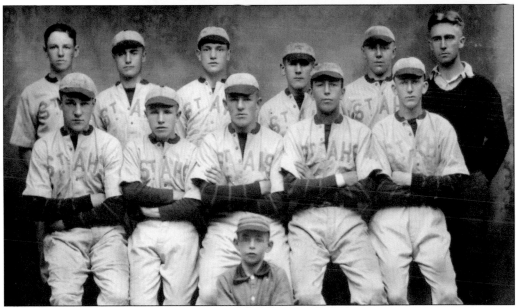

Here is a look at the 1922 Vermont State Baseball Champions of St. Albans High School. Coach John Roche (wearing sweater) called this his best team ever. With nary a smile on anyone's face, this bunch of sluggers must have played for real. Even the mascot, Master Perron, sees it the same way. Pictured are, from left to right, (first row) Master Perron; (second row) shortstop Cleon "Goat" Lambe, left fielder Ray Lanuette, captain and pitcher William "Puffer" Willis, first baseman Irving Willett, and third baseman Dana Buckley; (third row) right fielder B. Berrie, center fielder Robert Alexander, right fielder Edward Maloney, second baseman Max Godfrey, catcher Ed "Bo" Willis, and coach John Roche.

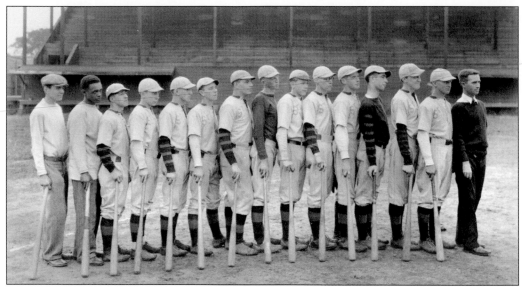

The St. Albans High School baseball team from 1928 is shown standing with their coach John Roche, far right. From left to right are William Thorpe, Jesse Williams, Donald Lawrence, Ernest Webster, Norman Godfrey, John Nash, James Carter, Orville Cummings, Nelson Lewis, Harold Montgomery, Leonard Sweeny, Robert Sullivan, John Meunier, and Orson Jay. When H. B. Dickinson became principal, his long-term goal was to have an athletic field, and on June 12, 1923, Coote Field was dedicated after St. Albans defeated their old rival, Plattsburg, 7-0.

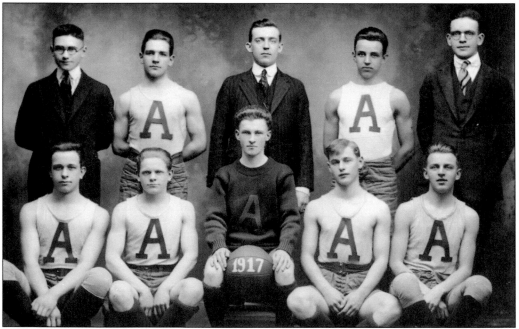

Basketball was new to St. Albans High School in the 1916–1917 season. The lack of a school gymnasium was the principal difficulty in supporting the team, which did survive to become a vital contender in its league. Pictured here are, left to right, (first row) Elmer Brackette, Robert Buck, Eliaha Corrigan, Charles "Babe" Shannon, and Walter Finn; (second row) Earl Brown, Arthur Sheehan, "Doc" Crowley, Chandler Davis, and Walter Cummings.

Baseball was inaugurated at St. Albans High School in 1891; however, the community already had a league team. These two images support the popularity of baseball, depicting the involvement of St. Albans with the Northern Base Ball League in 1903. The schedule at right indicates the league of the time: Burlington, Rutland, and Plattsburg. Baseball fans could take the railroad, which often ran specials to the games. The Northern League would survive into the 1950s, with the Giants located in St. Albans. Two local baseball figures stand out: Paul Guertin was a tramp, or local player, who was catching for the Giants when they won the pennant in 1950, and Angelo "Chet" Massa came to St. Albans from Rhode Island in 1946 to play ball, remaining here as a teacher at Bellows Free Academy, where he served as headmaster from 1973 to 1983.

OFFICIAL SCHEDULE

OF THE

Northern
Base Ball League

FOR THE

Season of 1903.

Presented by

C. H. PLACE, Jeweler,
144 MAIN STREET.
St. Albans, Vermont.

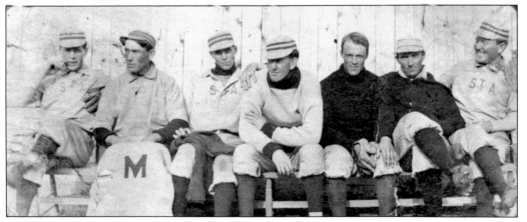

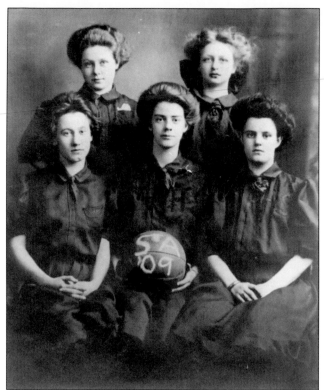

When the Girls' Athletic Association was created in 1908, it struggled against the belief that playing sports was not a dignified outlet for a young girl's energy, but under the leadership of Alberta Beeman and student Eleanor Hatch, a sports association was formed. At left is the first St. Albans girls' basketball team in their 1909 state championship photograph. They were undefeated. Pictured are, left to right, (first row) Irene Graves, Eleanor Hatch, and Pauline Thompson; (second row) Helen Bronson and Jennie Shaw. Fifteen years would pass before another team would play in 1923. Below are, from left to right, (first row) Lucile Richard, Marion Collins, Alfreida Chase, Christine Curry, and Katherine Wheeler; (second row) Grace Hoffman, Irma Revoir, Barbara Moore, Lulu Sweeney, and Leo Papineau (coach).

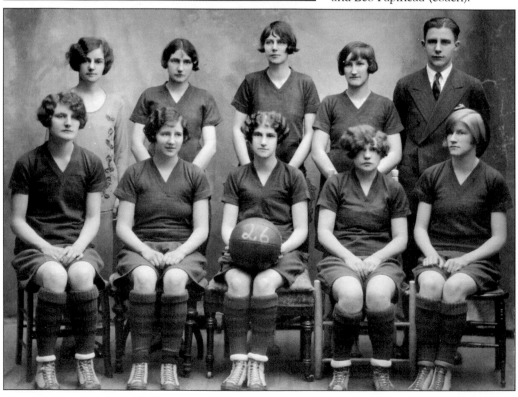

Seven

ENTERTAINMENT AND CIVIC EVENTS

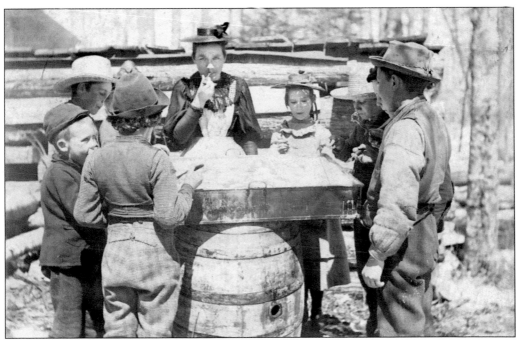

St. Albans has a long history of cultural presentations, civic celebrations, and amusements. Stage productions, choral concerts, festivals, and parades were common. Among the numerous opportunities to celebrate was the sugar-on-snow party, a popular spring event. St. Albans has billed itself the maple capital of America and celebrates all things maple with an annual festival that started in 1967. This photograph depicts a schoolmarm with her pupils sampling some of this sweet treat in the early 1900s.

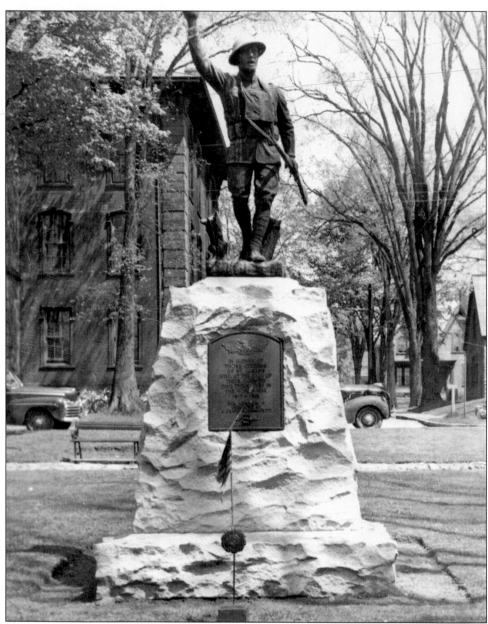

Since November 11, 1923, Ernest Moore Viquesney's *The Spirit of the American Doughboy* has stood in Taylor Park. It was designed to honor the veterans and casualties of World War I. Most of the doughboys were not cast but rather made of light metal sheets, most commonly bronze or brass. The doughboys are 7 feet tall and weigh a surprisingly light 200 pounds. The doughboy is wearing a British steel helmet resembling an inverted basin along with standard World War I leggings. He carries an M-1903 bayonet-equipped rifle and a grenade. On his upper body can be seen a knapsack, canvas gas mask pouch, and a web cartridge belt. The most commonly accepted origin of the word doughboy is the baked goods theory. The soldier's meal staple was a doughy flour and rice concoction cooked over a fire. Another, the buttons theory, is that the infantry soldiers' uniform buttons resembled dumplings. While the origin of doughboy is thought to have originated in World War I, it was actually used a century before.

Committees

Chairman General Committee
HON. E. C. SMITH

Executive Committee
FULLER C. SMITH, Chairman
S. S. CUSHING
W. H. FINN
J. J. THOMPSON
E. R. THIBAULT
G. B. WHITE
GEO. GROSSMAN

Treasurer: N. N. ATWOOD
Secretary: H. WEBBER

American Legion War Memorial Committee
G. B. WHITE, Chairman
H. WEBBER
C. E. PELL

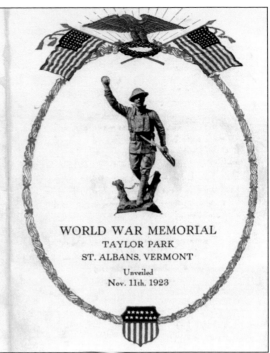

WORLD WAR MEMORIAL
TAYLOR PARK
ST. ALBANS, VERMONT

Unveiled
Nov. 11th, 1923

November 11, 1923, marked the unveiling of E. M. Viquesney's monument to the soldiers of World War I. Organized by the American Legion, it was to be a memorable day. Other groups that assisted in this celebration were local, fraternal, and social organizations. The 3:00 p.m. parade under the direction of Marshal Capt. C. E. Pell snaked through the business district, ending at the monument in Taylor Park. Comdr. Justis Moore led the unveiling of the Visquesney monument, and Mayor Fred Collins accepted the statue on behalf of the citizenry. The playing of "The Star-Spangled Banner" and "Taps" concluded the ceremony. St. Albans sent 525 men to the war, and all but 26 returned. *The Spirit of the American Doughboy* honors those men who battled and died under the flag of their country in World War I.

History will record that 525 men served in the World War 1917-18 from St. Albans and its vicinity. In that war twenty-six made their last great sacrifice—the gift of their lives that liberty and civilization might endure. In honor of these, Green Mountain Post No. 1, American Legion and the religious, fraternal and social organizations and more than forty-three hundred men, women and children of St. Albans have contributed to the erection of this monument and now dedicate it to the glory and honor of those who battled and died under the flag of their country.

Program

Sunday afternoon, November 11th, 1923
at 3 o'clock

Parade · · Capt. C. E. Pell, Marshal
via Main, Kingman, Federal, Lake, Main, Bank,
Church and Fairfield Streets to Monument.

Unveiling Ceremonies
Chairman · · · · Major S. S. Watson
Invocation
Rev. Stanley Cummings
Chaplain Green Mountain Post No. 1, Am. Legion
Unveiling of Statue
J. G. Moore
Commander A. R. Hurlbut Post No. 60, G. A. R.
Address
Hon. John Q. Tilson · New Haven, Conn.
Selection
Soldier's Farewell · · St. Albans Glee Club
Remarks
Chas. N. Barber
Commander American Legion Dept. of Vermont
Acceptance of Statue on behalf of citizens
Mayor F. A. Collins
Benediction · · · Rev. Stanley Cummings
Star Spangled Banner Taps

Men from St. Albans have served their state and country from the earliest times. In November 1872, the State of Vermont organized the miscellaneous military organizations that had accumulated since the War of the Rebellion. This task was accomplished in 1873, and Company B was established. Company B was mustered into the U.S. service in May 1898 for the Spanish-American War. Since the reorganization of Company B in 1899, the unit has reported for every duty ordered, and with nearly full strength. Company B is assigned to the 1st Battalion, 1st Infantry of the Vermont National Guard and is stationed at the armory on Fairfield Street. The above photograph depicts Company B in 1920. The photograph below shows the 1st Infantry Vermont National Guard Machine Gun Company on the city hall steps before its departure in 1917.

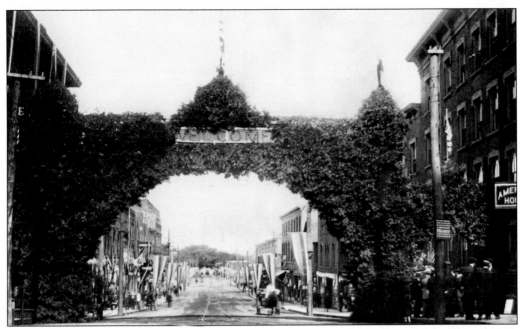

This arch at the top of Lake Street was made in anticipation of the Peace Celebration in 1914. The Treaty of Ghent was signed on December 24, 1814, allowing the return of friendly relations between the United States and Great Britain. Other British possessions, including Canada, planned elaborate parades, the significance of the treaty was so great. The trolley tracks can be seen heading down Lake Street with bunting on the fronts of the buildings and banners on the poles.

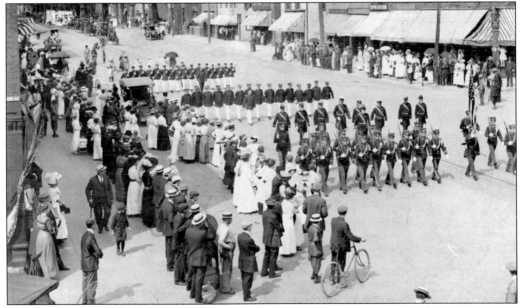

This parade, dated July 16, 1913, shows everyone dressed in their finery, men and women wearing hats, and some ladies with their parasols open to protect their skin from the sun. This photograph was taken at the corner of North Main and Bank Streets. The first row shows Company B of the Vermont National Guard, the second row the Knights of Columbus, the third row the Knights of Pythias, and, lastly, Woodmen of America are shown holding their axes.

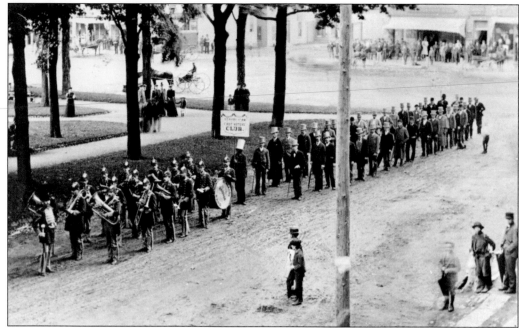

This parade, around 1893, shows the Republican First Voters' Club dressed to the nines with their top hats and canes. In front of them stands the St. Albans Brigade Band ready to march. It is said the band was given its name after it played for the National Guard Brigade. This group stands on Bank Street with Taylor Park to the left and Main and Kingman Streets in the background.

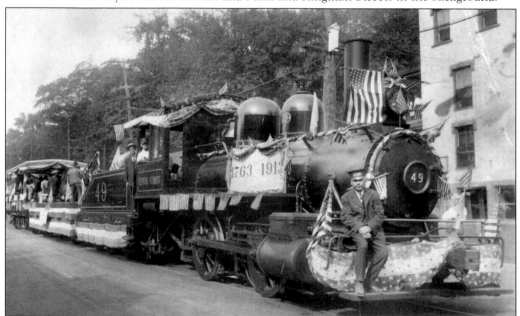

The trolley tracks in St. Albans could also accommodate trains, as depicted in this photograph of the Central Vermont engine No. 49 passing the foot of Fairfield Street and heading south during the parade of 1913. The building at the right is the Park View Hotel, originally the Stratton, which has considerable history, having incarnations as a garage, a service station, and a tire shop. The building was razed in the 1960s and is now the location of Handy Toyota.

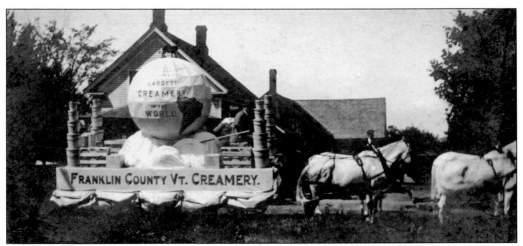

These two photographs depict the Old Home week parade, August 16, 1901, on Main Street. The Vermont Legislature of 1900 established Old Home Week and set aside August 11–17, 1901, for the homecoming of all absent sons and daughters of Vermont. The 14 towns in Franklin County united in observance of Old Home Week in St. Albans, where an estimated 15,000 to 20,000 locals and former county residents enjoyed the festivities. A mammoth tent was erected at Taylor Park for the festivities, and former residents were welcomed there by Mayor O. L. Hinds. The great event of the day was the grand military, civic, industrial, and floral parade. Note the claim made by the Franklin County Vermont Creamery: "The largest Creamery in the World." The picture below shows the C. L. Curtis Furniture Store just south of the intersection of Kingman and Main Streets.

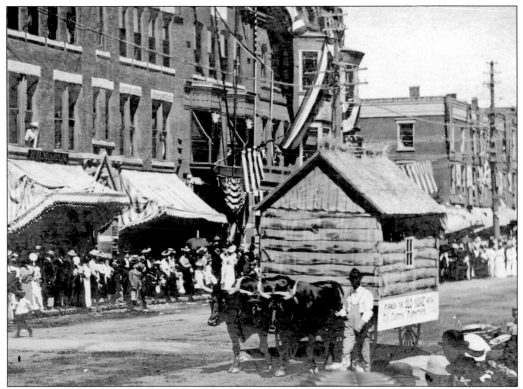

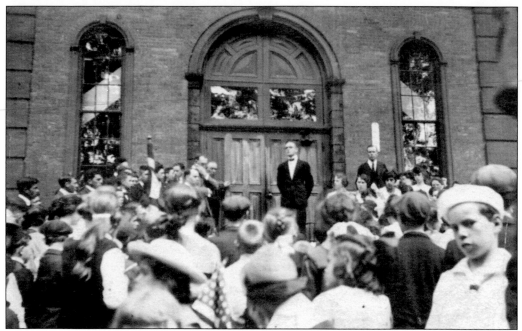

A variety of diversions were available to the people of St. Albans in addition to civic events, theater, concerts, and festivals. During the 1920s, the armory was the site of a car show, with some 50 models on display. There were poultry and homemaker shows, and citizens were also invited to attend dedications, as depicted in this photograph at the St. Albans Church Street School during the unveiling of a service flag in 1918. H. B. Dickinson, principal, is seen on the steps at the right.

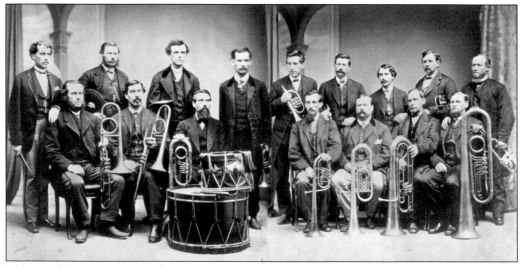

The St. Albans Brigade Band was said to have been created in 1856 when the St. Albans Cornet Band was formed in association with the Ransom Guard and Barlow Grays. The first leader of the St. Albans Brigade Band was Henry Hatch, and the band played at the dedication of the Bennington Battle Monument, the Sherbrooke Fair, the Philadelphia Exposition, and many conventions. In their youth, Sterling and Orrie Weed played with the band.

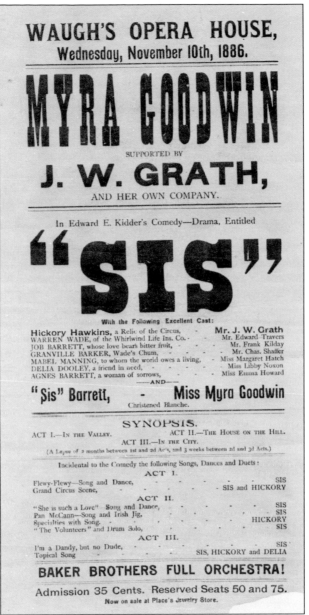

WAUGH'S OPERA HOUSE,
Wednesday, November 10th, 1886.

MYRA GOODWIN

SUPPORTED BY

J. W. GRATH,
AND HER OWN COMPANY.

In Edward E. Kidder's Comedy—Drama, Entitled

"SIS"

With the Following Excellent Cast:

Hickory Hawkins, a Relic of the Circus, -	Mr. J. W. Grath
WARREN WADE, of the Whirlwind Life Ins. Co. -	Mr. Edward Travers
JOB BARRETT, whose love bears bitter fruit, -	Mr. Frank Kilday
GRANVILLE BARKER, Wade's Chum, -	Mr. Chas. Shaffer
MABEL MANNING, to whom the world owes a living,	Miss Margaret Hatch
DELIA DOOLEY, a friend in need, -	Miss Libby Noxon
AGNES BARRETT, a woman of sorrows, -	Miss Emma Howard

——AND——

"Sis" Barrett, - Miss Myra Goodwin
Christened Blanche.

SYNOPSIS.

ACT I.—In the Valley. ACT II.—The House on the Hill.
ACT III.—In the City.

(A Lapse of 2 months between 1st and 2d Acts, and 3 weeks between 2d and 3d Acts.)

Incidental to the Comedy the following Songs, Dances and Duets:

ACT I.

Flewy-Flewy—Song and Dance, -	SIS
Grand Circus Scene, -	SIS and HICKORY

ACT II.

"She is such a Love" Song and Dance,	SIS
Pan McCann—Song and Irish Jig, -	SIS
Specialties with Song. -	HICKORY
"The Volunteers" and Drum Solo,	SIS

ACT III.

I'm a Dandy, but no Dude, -	SIS
Topical Song -	SIS, HICKORY and DELIA

BAKER BROTHERS FULL ORCHESTRA!

Admission 35 Cents. Reserved Seats 50 and 75.
Now on sale at Place's Jewelry Store.

Dr. Theodore R. Waugh built the Opera Block at 24 North Main Street in 1883, and its earliest use for a stage performance was in 1884 for the *Merchant of Venice*. Stage presentations were held on the second floor, while the first floor was rented to Twigg Brothers, clothiers. After the fire of 1891, a second opera house was completed. Patrons enjoyed plays, vaudeville acts, concerts, and early motion pictures for 33 years. Professionals and local citizens were involved in a variety of presentations there. Among the celebrities appearing were the Marx Brothers and John Philip Souza. Troupes en route to Canada were required to stop for customs inspections and rather than lose the day and revenue in transit, they would arrange to play in St. Albans. Carloads of stage scenery and costumes would line the sides of streets, causing quite a stir of excitement for the upcoming show. With the advent of cinemas, the Waugh Opera House eventually closed, and its space was remodeled into apartments. The item pictured here announced the performance of *SIS*.

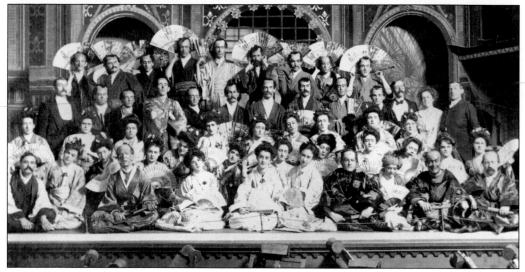

St. Albans has always taken its music seriously. It is recorded that Miranda Aldis Kellogg brought the first piano to St. Albans in 1822, and soon afterward, an organ was installed in the Episcopal church. Singing schools were organized in 1839. The Baker family gave a choral concert at the courthouse with a melodeon accompaniment. The St. Albans Brigade Band was organized in 1856 and performed until 1926. In 1900, anyone who could sing could join the glee club. Many operettas and cantatas were performed. One of the most successful was Gilbert and Sullivan's "Mikado." Among the company were John Weeks as the Mikado, Frank Greene as Koko, and Mrs. John Weeks as Kitty-Poo. The item below, from an 1884 opera house program, is evidence that theater-appropriate comportment was expected at all opera house performances.

$5.00 REWARD.

Complaint having been made of disorderly conduct in the Opera House Balcony, and having thus far been unable to get sufficient evidence against the persons making it, we will give the above reward to the person furnishing evidence sufficient to convict any person or persons of illegal conduct.

MANAGEMENT OF OPERA HOUSE.

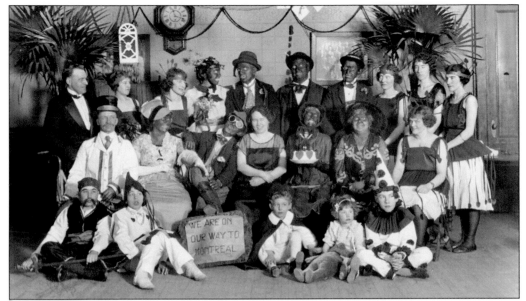

This 1924 photograph shows members of the St. Albans chapter of the Knights of Pythias, a fraternal organization, founded in 1864 by Justus H. Rathbone. The ideals of loyalty, honor, and friendship form the foundation of its mission. Some of the order's auxiliaries are the Pythian Sisters, a dramatic order, and two youth organizations. The members of the chapter are posing for a current dramatic performance. The Knights of Pythias met on the third floor of the Morton Block at the southwest corner of Lake and Main Streets.

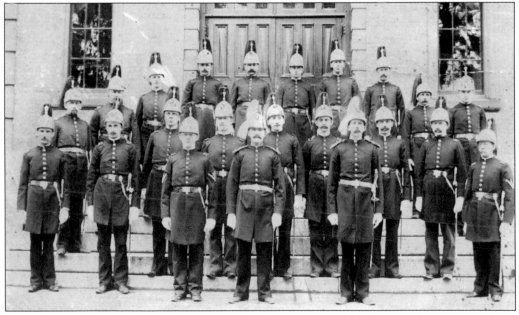

The St. Albans Knights of Pythias are standing at attention in full dress uniforms on the front steps of the St. Albans Academy in the 1880s. The Knights of Pythias are international in scope, nonsectarian, and dedicated to world peace. A member must be 18 years old or older, cannot be a professional gambler, or involved with illegal drugs. Currently there are approximately 2,000 lodges worldwide with over 50,000 members.

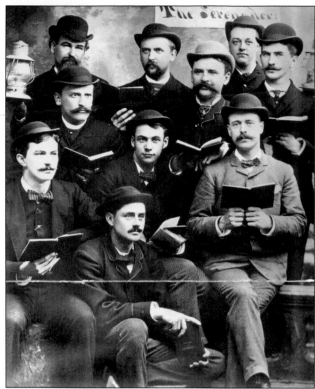

In late 1878, six young men sat in the back of the Jacques' grocery store, their usual gathering place for listening to the day's latest gossip, when they decided they preferred a unique, private space for conversation. With T. H. Manley as their president, the Young Men's Social Club of St. Albans was formed. After several moves, around November 1, 1882, they renamed themselves the Owl Club. The club enjoyed music, and this 1885 photograph shows the Serenaders, part of its glee club.

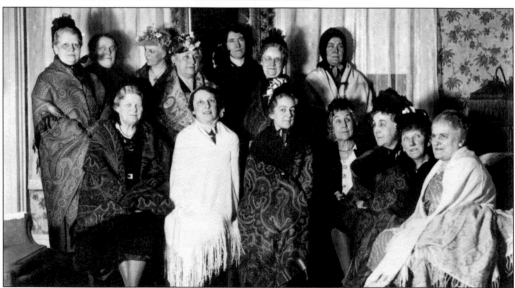

This 1930s Daughters of the American Revolution shawl party held at the home of Helen Dunbar at 44 Diamond Street shows a variety of shawl styles and materials. Helen Dunbar is shown second from the left in the back row. All of the women pictured are members of the Daughters of the American Revolution, an organization whose membership is limited to women who "can prove lineal, blood line descent from an ancestor who aided in achieving American independence." The goals of the Daughters of the American Revolution, founded in 1890, are patriotism, education, and historic preservation.

Eight

CHURCHES AND PUBLIC BUILDINGS

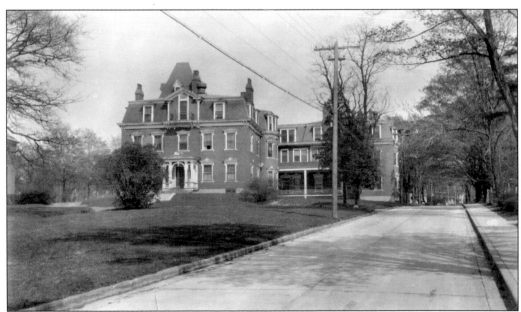

A drive through St. Albans via Route 7 would entice the traveler to explore more of the beautiful public buildings, churches, and residences tucked throughout the city. This is St. Albans Hospital viewed from the corner of Main and Ferris Streets around 1955. It was established in 1883. Chauncey Warner purchased Rose Hill from the Smith family and donated the land and Colonial house to be used as a hospital. There were several additions over the years, and it is now the north campus of Bellows Free Academy.

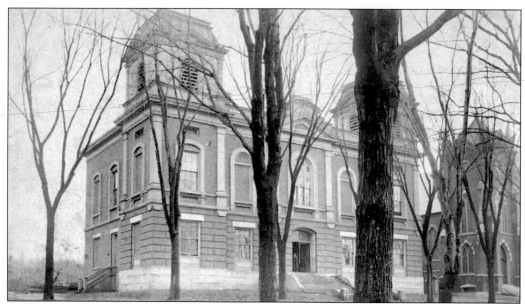

In 1793, St. Albans became the seat of Franklin County and, therefore, needed a place to hold court. The first court was held in Silas Hathaway's farmhouse/tavern on North Main Street, which still stands today. The first courthouse was built in 1800 and enlarged in 1830. During its existence, the courthouse was also used by local churches for services and meetings. It was razed in 1874, and a new renaissance revival courthouse was built at a cost of $75,000. Today this courthouse still stands and functions primarily as a probate, superior, and small claims court.

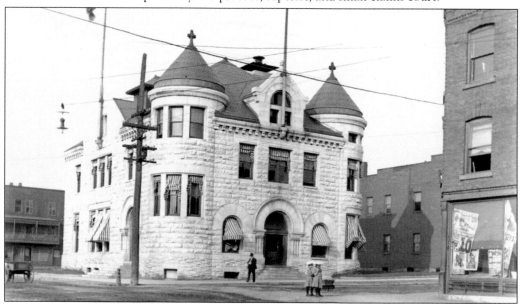

This unique white marble building at the corner of Federal and Kingman Streets was constructed in 1895 at a cost of $110,000. It served as the U.S. Post Office and Customs House. Shortly before its completion, the great fire of 1895 destroyed its interior. Since the building was structurally sound, it was restored and served in its original capacity until 1938, when a new building was constructed on South Main Street. Since then, the building has served as a courthouse, a Vermont Department of Motor Vehicles office, and is currently the property of the Peoples Trust Company.

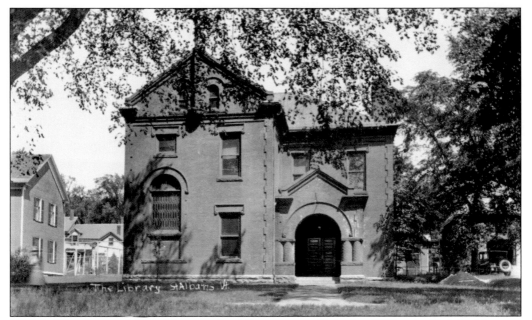

With 2,600 volumes, the first library in St. Albans was established in 1855 and called the Vermont Central Library Association. In his will of 1861, Henry J. Hunt left $1,000 for a public library, provided the village raised a matching amount. Within a year's time, the amount was raised. In 1877, the books were placed in a reading room offered by Herbert Brainerd and, as pictured here, the present library on Maiden Lane was completed in 1902.

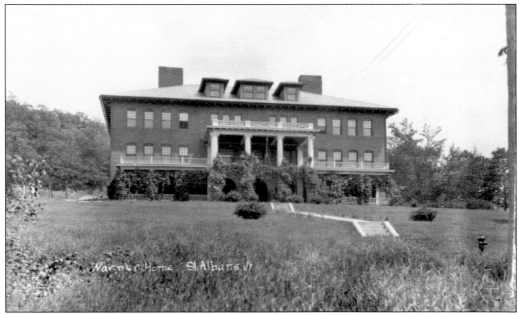

The Warner Home for Little Wanderers was established in 1881 in the home of Mr. and Mrs. M. H. Warren on Brown Avenue with funds provided by Chauncey Warner, Esq. The residence became too small, and in 1882, Mr. and Mrs. Warren moved into this building on High Street at the top of Upper Newton Street. Today the Chauncey Warner Trust provides college scholarships, and the building has been converted to condominiums.

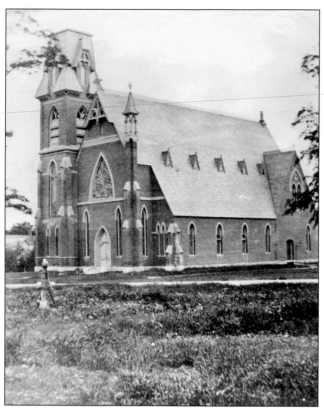

Around 1860, Daniel M. Walker opened his home to be used as a place of worship for the small number of Baptists residing in St. Albans. Rev. J. F. Bigelow was sent by the Convention to assist them organizing. Articles of faith and church covenant, regulations of the church, and rules of order were adopted on January 17, 1866, by 24 members. In June 1870, Rev. M. G. Smith began as pastor, and under his leadership a site was purchased on Congress Street. The completed church was dedicated December 23, 1874. A fire was discovered on May 10, 1883, leaving some of the walls salvageable. The present church stands on the same foundation with the same dimensions, though the belfry was shortened and capped when rebuilt in 1886.

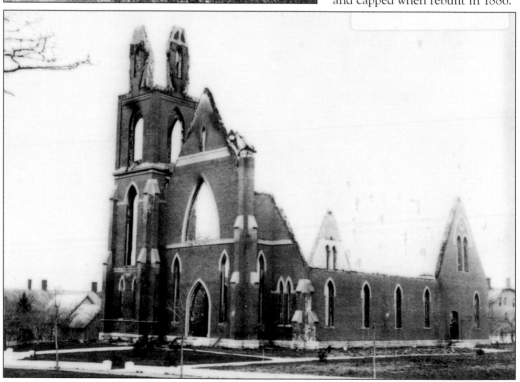

The Congregational church was organized in 1803, and its first church was built in 1826. It was replaced by a second church in 1863. The church in the photograph at right, on the corner of Bank and Church Streets, was destroyed by fire in 1891, and it was replaced in 1894 by the church seen in the photograph below. Services in the interim were conducted at the courthouse next door. There have been several renovations to the interior, one of which was to create a center aisle in the sanctuary. Especially admired about the church are two Tiffany stained-glass windows donated by Gov. J. Gregory Smith in 1894 in memory of his wife, Ann Brainerd Smith. The steeple clock continues to provide accurate time and is wound by a society of clock winders. There is a piece of the original bell from the first church on display at the St. Albans Historical Museum.

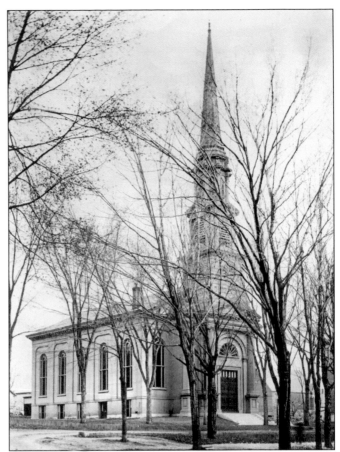

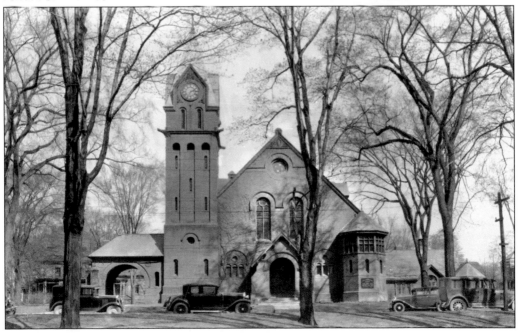

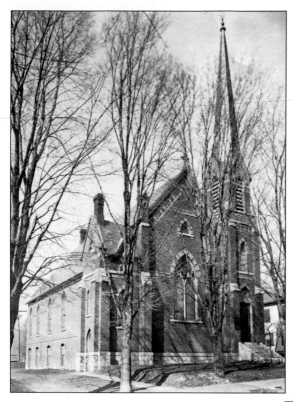

The Universalist church, which stood on Bishop Street just up from the St. Albans Historical Museum, was completed May 1, 1883. After a tent meeting in early Nazarene fashion in 1930, the Church of the Nazarene was organized, and in 1937, the former Universalist church was purchased. From 1852 to 1954, the entire building was renovated and redecorated. The congregation moved to a new church on Upper Welden Street, and this edifice was razed in 1981.

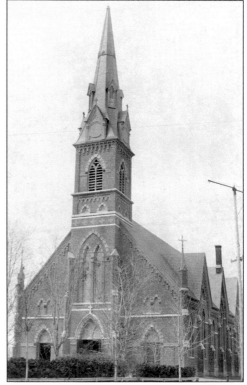

With the establishment of the Central Vermont Railroad headquarters and construction of offices and shops, job opportunities drew French-speaking Quebecois to St. Albans, adding to the already considerable number of Francophones here. In October 1872, Bishop DeGoesbriand approved a new parish, eventually known as Holy Angels, for the French of St. Albans. Services were held in the basement until its completion in 1886. The spire was struck by lightning in May 1917, and it was replaced in August 2000.

Our Lady of the Lake on Church Road at St. Albans Bay began as a mission church. It eventually was assigned a full-time pastor, and all the rites of the Catholic church were performed there for a congregation of primarily farmers from St. Albans Town and Georgia. The basement served for meetings, suppers, and religious classes taught by the nuns from Holy Angels. The parish was eventually closed, and the church and rectory were sold to a private developer and demolished.

In 1816, the Episcopal congregation conducted services in the old Franklin County Courthouse on Church Street. In 1824, the congregation built a modest wood structure on the corner of Fairfield and Church Streets. The edifice was replaced to accommodate a growing congregation, and after a fire in 1858, the present church was erected in 1860 using the famed St. Albans calico stone. A remarkable feature of St. Luke's is its chime of 10 bells that ring out twice daily.

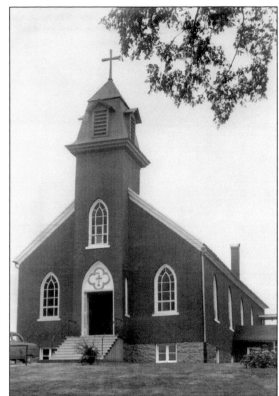

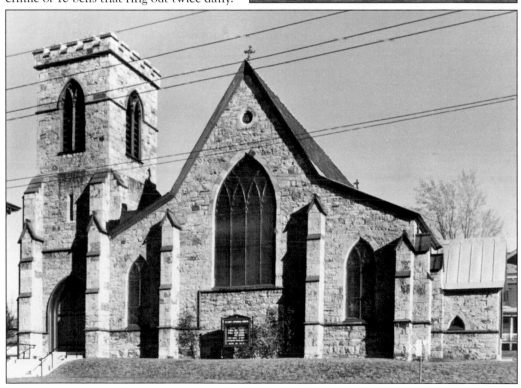

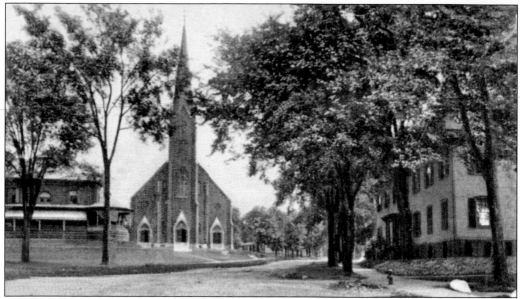

St. Mary's Catholic Church on Fairfield Street was begun in 1848 and completed in 1864. The original building shown with its spire in the above photograph was administered by the Diocese of Boston, but by the year of its dedication, it was part of the Diocese of Burlington. St. Mary's ministered to both French and English-speaking Catholics of the area until Bishop DeGoesbriand ordered the formation of a new French parish in 1872. The spire was removed in 1922, having been weakened by lightning. Visitors to this church today would note that just in front of the church there is a statue of Saint Alban, for whom the village is named. One of the church's lovely stained-glass windows also depicts him. Villa Barlow, across the street, was home to a parish school, and an increase in enrollment necessitated a new two-story brick schoolhouse, built in 1874 for $2,553 and located adjacent to the church on Lincoln Avenue.

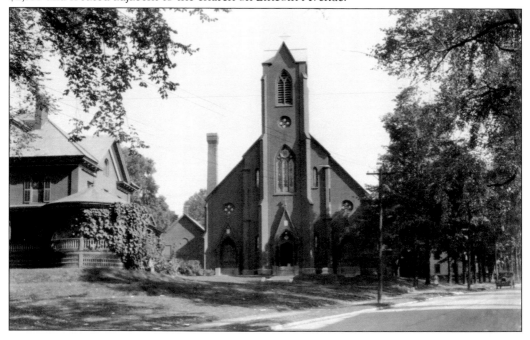

In 1801, the St. Paul's Methodist Church was established, with Laban Clarke preaching, followed in 1802 with Rev. Joel Foster. The old academy building was used by the Methodist Society for preaching and prayer meetings in 1812. Land was purchased at the present site on Church Street between the courthouse and the St. Albans Historical Museum. Work was done between 1820 and 1821 and was the first place of worship in town. In 1875, the structure was removed and building for the new church was begun, but the structure was not completed until 1880. The beautiful spire seen in the postcard at right was replaced in 1918 with a Gothic tower, as shown in the photograph below. Many of the trees seen here in Taylor Park had to be cut down in later years because of Dutch elm disease or old age. The walkways are now paved, and some have been replaced with a porous material to protect the environment.

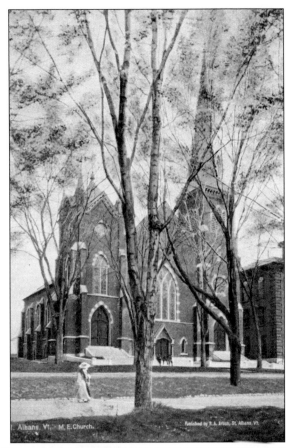

Pictured here are some of the Sisters of the Congregation of Notre Dame in front of their original residence, Villa Barlow, on Fairfield Street across from St. Mary's. The nuns arrived in 1869, purchased the Barlow estate, and demolished the original building. They retained some of the woodwork for use in the new building, which also served as a school for girls. In 1873, an annex was added to the house to provide better accommodations for students. St. Mary's Parish House now stands on this site.

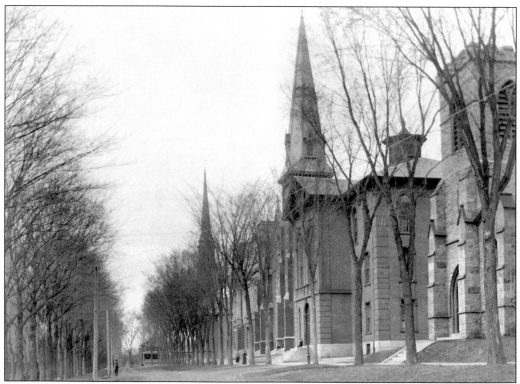

The 1880s photograph looking north on Church Street shows St. Luke's Episcopal Church, St. Albans Academy, St. Paul's Methodist Church, the Franklin County Courthouse, and the First Congregational Church, respectively, on a quiet day. Evidence of horse travel along the dirt street and a variety of building frontages can be seen. The church spires and many trees seem to be climbing to the sky, creating a cavern through which life on the ground passes. Today most of the trees are gone, and Church Street is paved.

Nine

HOUSES AND SCENES

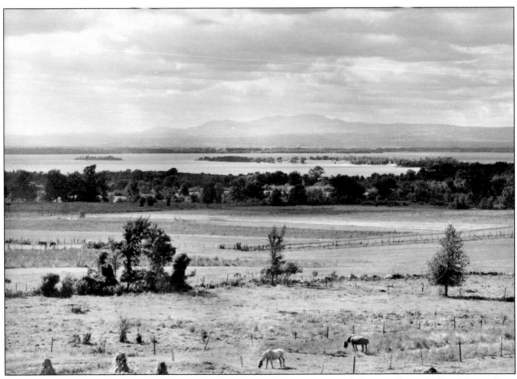

The hills to the east of St. Albans offer a magnificent panorama of the northern Lake Champlain valley. This view from the overpass on Route 7 south in St. Albans Town offers a sampling of the farmland, St. Albans Bay, Hathaway Point on Lake Champlain, the majestic Adirondack Mountains in New York State, and the Lake Champlain Islands. From St. Albans Hill, one can see farther north to Maquam Shore, and on a clear night, the glow of the lights of Montreal is visible.

Winter in St. Albans in the mid-1920s could make for some tough truckin'. The deep snow and drifts have given the drivers and their two plow trucks a real challenge on their way to St. Albans. While the drivers are nearly buried along with their trucks, they are still smiling on this crisp, sunny day. In the background can be seen the house and barn of the Gallagher Farm at Gallagher's Corners.

This 1920s winter scene on Lake Street faces Main Street and Taylor Park. Of the two men standing near the gasoline pump and Socony sign, the one on the left is Bert Vail. The two horseless carriages parked near the men will offer a very cool ride to their owners. Across the street, the old standby—a horse and sleigh—seem to be quite fitting for this season. A steam laundry is also seen, and H. Harris's department store is well into the winter portion of its fall and winter sale.

This image depicts the fire lookout tower on Bellevue Hill, east of St. Albans, around 1870. There was a small park there for picnicking and sightseeing. In 1951, this became a U.S. Air Force installation, home to the 764 Radar Control and Warning Squadron. During the station's busiest years (1951–1955), about 400 airmen were posted there. The base was decommissioned in 1979. Only one of the five radomes remains administered by the Federal Aviation Administration.

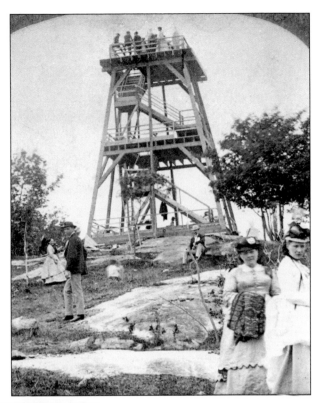

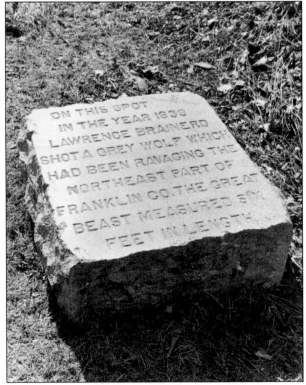

Aldis Hill on the northeast side of St. Albans is a 60-acre site still used for recreation. The Aldis Hill Playground Trust was established on land owned by Asa O. Aldis, a local attorney and judge. Today this 500-foot hill still provides forested trails and dramatic views of the Champlain Valley to the west. On its east side, Aldis Hill abuts Hard'ack, a popular winter recreation area. This monument indicates the location where Lawrence Brainerd killed a wolf that had been ravaging local livestock. He gave the bounty for the wolf's head, $20, to the other hunters.

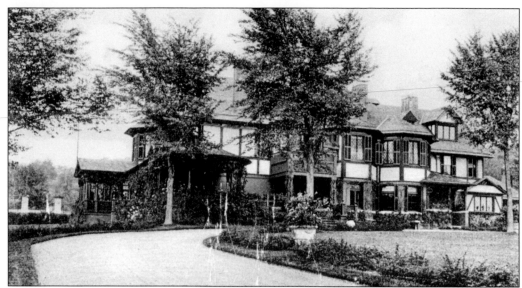

The original Seven Acres was the residence of Gov. Edward C. Smith and his family. Its Tudor style, with beautiful lead-framed glass windows, was located at the top of Congress Street and was destroyed by fire on November 4, 1924. A booklet containing a list of all the items lost or saved was written, noting the losses by the servants as well. With this long list, it gave common people an insight as to how the wealthy lived.

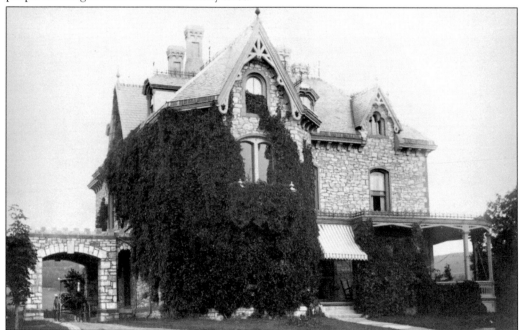

In its heyday, Redstone Villa had many prominent owners: Worthington C. Smith, John W. Newton, William Stanford Stevens, Charles S. Schoff, and Dr. G. C. Berkley, who was rumored to have thought of turning it into a sanitarium but chose to make it his private home. Now this grand home, made of Swanton red marble, is known as the Redstone Villa Nursing Home and is located on Forest Hill Drive. In this early photograph, a horse and carriage wait under the porte cochere.

The St. Albans Street Railway Company was chartered in November 1892, but the charter lapsed due to a lack of $1,000 in capital. They rechartered on November 2, 1900, and, with great fanfare, opened to the public on July 4, 1901. This photograph was taken from the lower end of Lake Street looking east. The trolley intersection over the many train tracks on Lake Street was considered the most dangerous segment of the trolley line. In 1921, after 20 years of operation, the trolley ended its service.

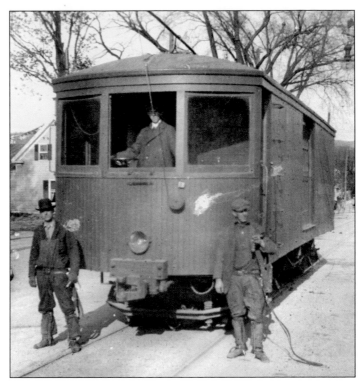

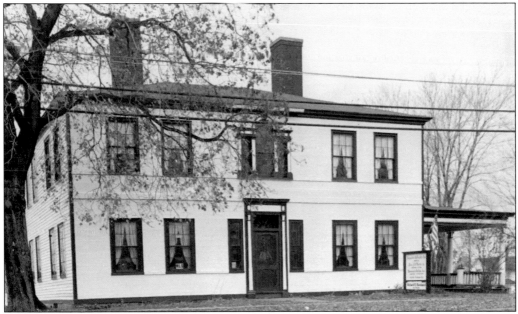

The Houghton House, now the Brady and Levesque Funeral Home on South Main Street, was built in 1800, the second oldest house in St. Albans. It was bought by Abel Houghton in 1828 and remained in the family for four generations. The only exterior change was the addition of a side porch in 1915. The Houghton House was part of the Underground Railroad, and three tunnels entered and exited it. When Main Street was repaved in 1956, these tunnels were destroyed, mostly to control rats.

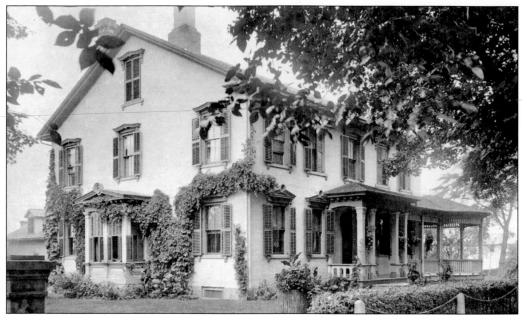

The Brainerd House of Herbert Rawson Brainerd became the Stranahan House when daughter Miranda married Farrand Stewart Stranahan in 1898. Stranahan had come to Vermont from New York City in 1859 and enlisted in the Vermont Cavalry during the Civil War, at which point he became a first lieutenant. The Stranahan House was an active station of the Underground Railroad during both Brainerd's and Stranahan's ownerships. The Stranahan House still stands on the west side of North Main Street across from the downtown shopping center.

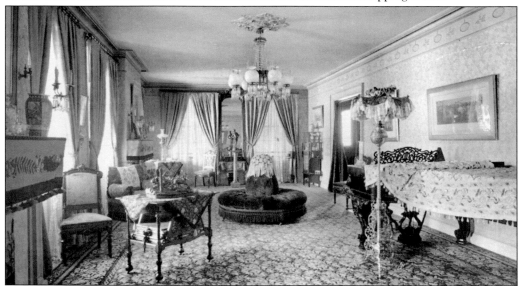

The Victorian style and furnishings of the Stranahan drawing room, while elaborate, still give the sense of spaciousness combined with warmth. Central ceiling lights, along with carefully placed sidelights, add to the softness of the room. Well-crafted moldings throughout this room further help to refine it. The Stranahan House has been made into upscale condominiums but still contains touches of its Victorian days. The parquet floor in the main foyer remains, and each unit contains a fireplace.

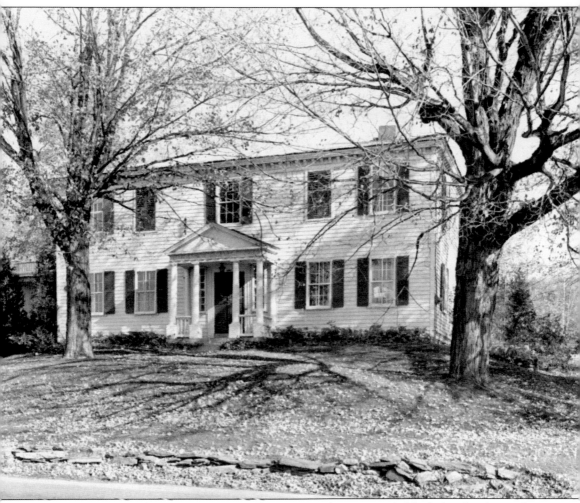

The first time Silas Hathaway came to St. Albans in 1788, he apparently liked what he observed, so the following year he returned with his family and household goods. They lived in a small wooden shelter made with some of the wood from their sleigh until 1793, when they began building a large wood-framed structure on what would be 255 North Main Street. The building was completed in 1794, making it the oldest house in St. Albans. It was originally used as a combination residence/tavern and soon was the gathering place of the community. Hathaway Tavern contained 20 rooms, including large meeting spaces utilized by the Franklin County Court, the Masonic Lodge, and a post office. The lumber supply was milled in Whitehall, New York, and arrived by barge. The house is approximately 45 feet in length and 33 feet in depth, with a beautiful ornamental cornice on all four sides. Around 1890, Julia Hoyt Lucas added a large porch on the south side. Throughout the years, Hathaway House has had several owners, the most recent being Randolph and Cathy Yates.

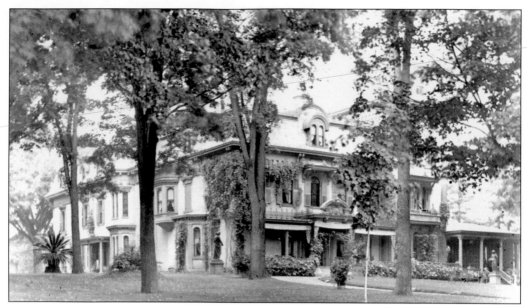

Over the years, the Smith descendants owned many exquisite homes in St. Albans. Pictured here is The Towers, built around 1852 by John Gregory Smith (1818–1891) and Ann Eliza Brainerd Smith on the southeast corner of Smith and Congress Streets. Many notables were entertained here, including Pres. Benjamin Harrison. Their daughter, Annie, married W. Beecher Fonda and occupied the 40-plus-room mansion, which was demolished in 1937 to make way for a structure better suited to modern conveniences.

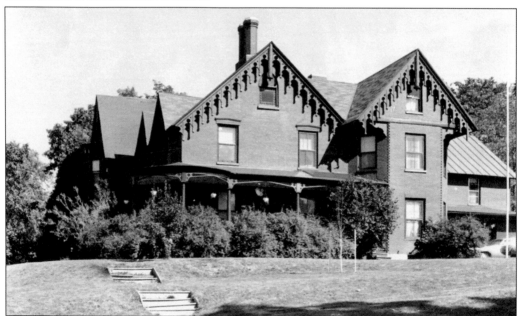

Today the home of the Richard Hersey family, the Gables is a brick Gothic Revival house that was built around 1850 by Lawrence Brainerd Jr. at 107 Bank Street. It was purchased in 1911 by Oliver Crocker Stevens whose wife, Julia, was the daughter of J. Gregory Smith. It was used by her family as a summer home. She would arrive with an entourage of servants ready to receive and entertain many famous operatic people who would visit this dedicated patron of the arts.

Bradley Barlow, born in Fairfield, Vermont, in 1814 was a farmer, merchant, banker, business entrepreneur, elected public official, and philanthropist. In 1837, he married Caroline Farnsworth of Fairfax, and in 1855, they moved to St. Albans and built a house at 151 North Main Street. Barlow became a cashier at the St. Albans Bank and remained in banking for most of his life. He died in Denver, Colorado, at the home of his daughter, Laura, from a hip injury suffered two years earlier. The Barlow House was razed in 1960 to make way for the St. Albans Shopping Center.

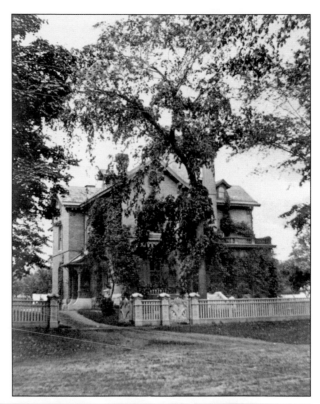

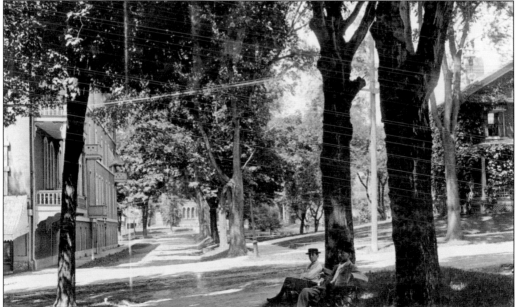

A pleasant day on the north side of Taylor Park in the 1880s shows a couple of young men relaxing in the shade of the trees. Straight ahead to the north is the First Baptist Church, while Bank Street passes left to right beside the young gents. The building in the left foreground is the Welden House, one of the finest dining and lodging establishments in St. Albans. Seen running through the trees are telephone lines—a sign of the growing technology ahead.

This photograph, taken in the early 1930s at the corner of High and Congress Streets and looking north, evokes the then tranquility of most residential neighborhoods. The houses visible on the west and east sides of the quiet tree-lined street remain much the same today. Notice that there are paved sidewalks and no stop signs or traffic lights. Also notice the fire call box on the utility pole, center left.

From the Hard'ack section of Aldis Hill, the viewer looks south toward Prospect Hill over the Smith-Fonda residence, The Towers, the southeast corner of Smith and Congress Streets, and the Worthington Smith house at the head of Bank Street in the late 1890s. Clam shells have been found on Aldis Hill within 3 feet from the surface, evidence of the time when water covered this entire region.

Ten

BUSINESS AND INDUSTRY

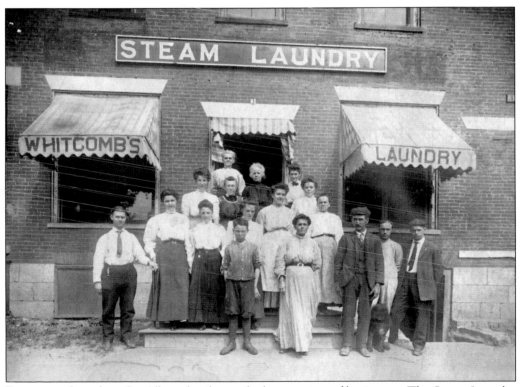

From its earliest days, St. Albans has boasted a large variety of businesses. The Steam Laundry on the northeast corner of Congress and North Main Streets was founded in 1885 by Wood and Gilson; however, it was operated for most of its history by the Gardner Whitcomb family. In 1931, the owners, Mr. and Mrs. Hayes Shangraw, closed the business and sold the property to Champlain Motors of North Main Street, after which the brick building was razed and a service station established.

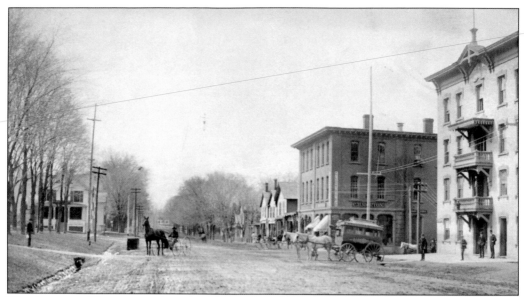

The American House, as it is known today, is located on the right side of this picture on the corner of Main and Lake Streets. Originally built as a two-story building in 1815, it was called the Bliss House, after its builder. Later it was called the Phoenix House, and now houses the chamber of commerce. The Morton clothing store was established in 1868 and prospered through the years of family ownership. Carroll H. Morton was the proprietor of the store at this time.

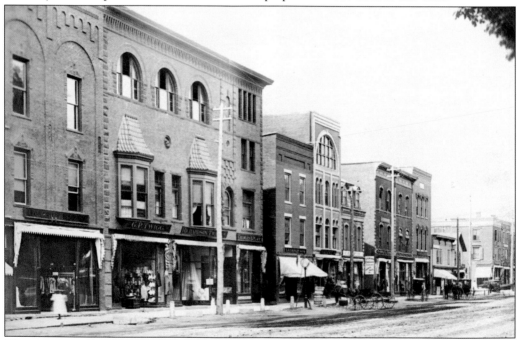

This view of the west side of North Main Street looking north is dated 1900, as indicated by the unpaved street. Among the businesses are the Place Jewelry Store and the G. P. Twigg clothiers in the opera house block. Twigg's store offered quality men's and boys' furnishings featuring well-known labels. Twigg was one of St. Albans's oldest and best-known businessmen. His residence at 85 High Street is currently the home of Dr. Ed and Mary Schumer.

The J. G. Moore Marble and Granite Works was established in Franklin County in 1856. By 1873, Moore and his business were settled at the corner of Congress and Main Streets. Moore specialized in cemetery work, including cleaning, lettering, building foundations, and resetting monuments. His long list of satisfied customers attests to his wide experience in cutting and handling stone.

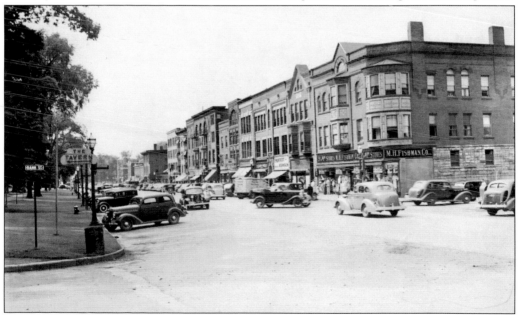

The M. H. Fishman Company building on the corner of North Main and Kingman Streets dominates this photograph from the mid-1930s with its second- and third-floor bay windows, removed in 1968. This photograph taken from the corner of Bank and North Main Streets looking south shows Taylor Park on the left, with a sign directing people to The Tavern. Notice the quaint street lamps and the delivery truck advertising Miracle Whip.

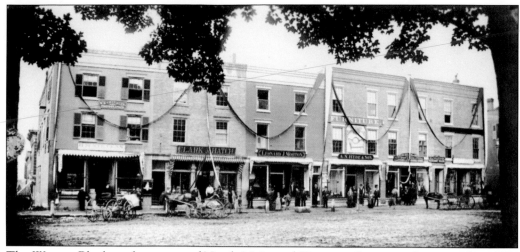

The Watson Block at the corner of North Main and Kingman Streets is shown in this 1870s photograph. A shopping center in a block, the businesses here met a variety of needs. W. D. Chandler provided photography service, and Clark and Hatch sold hardware for the home and business. Morton's clothing store offered the best in current fashion, and A. S. Hyde and Son provided furniture for the home. Staples at Scagel and Allen's were boots and shoes, and H. J. Watson did the tailoring. This entire center is abuzz with activity on this day.

The Green Mountain Oil trucks and their drivers stand ready to make deliveries in this 1939 photograph. Along with fuel oil, this D. J. Corliss-owned business offers automotive parts and accessories, as well as home appliances. Hope's Delicatessen provides the eats next door, and the Montgomery Ward store is ready to take a mail order. The shy building crouched between the larger buildings is home to the local Dodge, Plymouth, and Reo dealer. Above the main floor in this block are apartments. Watching over this busy scene is a lone biplane.

The St. Albans Messenger Building, shown at right, was located on the north side of Kingman Street and almost completely destroyed in the fire of 1895. The editor at the time was Frank Lester Greene, who, at first, was employed in 1891 as a cub reporter. His first words written as a reporter for the *St. Albans Messenger* were, "Ira Peters came to town yesterday and disposed of his potatoes." Who could imagine those few words would foretell a great career as an editor? He would later be elected to the U.S. Congress from 1912 to 1923, followed by the Senate from 1923 to 1929. In 1924, while in Washington, D.C., he was shot as a bystander to a clash between bootleggers and dry law enforcers. The masthead of the *Messenger* proclaims "Vermont's Oldest Evening Newspaper—1861." Below, is the staff in front of their office.

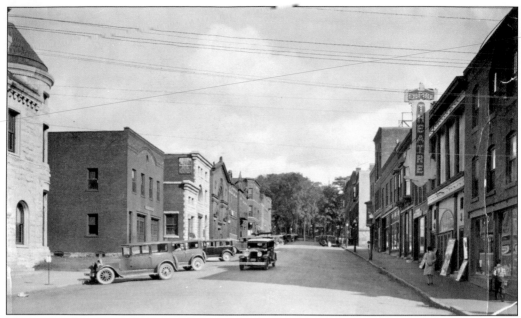

This view of Kingman Street in the 1930s looking east toward Taylor Park from Federal Street shows diagonal parking on both sides of the street. The second building on the left housed the fire station, and its neighbor to the east was Peoples Trust Bank. The next structure was the Welden Bank, eventually bought by the Peoples Trust, which now occupies all three of the above-mentioned buildings. On the right, notice the Empire Theatre sign and the billboards announcing the current movies.

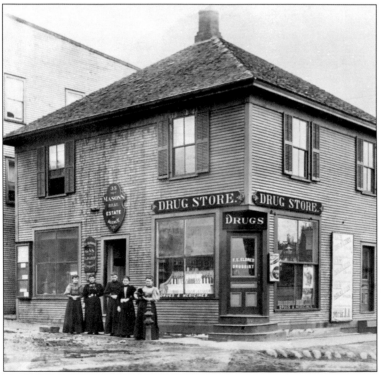

Around the time of this photograph, this wood-framed building contained the F. E. Eldred Drug Store, which sold the latest potions of the day, including the Pippin and New Brayton cigar brands. This was the office of the St. Albans Gas Company, which offered the latest gas ranges, heaters, and lighting appliances. The ladies pose in front of the Mason Real estate sign; one is holding the office "mouser."

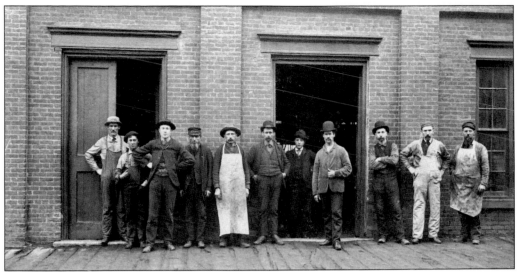

Among the city's early industries was the St. Albans Foundry on the northeast corner of Lake Street and Foundry Street, now known as Federal Street. The foundry building occupied extensive frontage on both streets. It was established in 1840 by Worthington C. Smith and did machine and foundry work. One of its chief products was the Old's patented horse-powered threshing machine. The foundry built an extensive trade throughout the United States, Mexico, Russia, Japan, Romania, Italy, and South America. The foundry operated until 1911, and the building has since been used as a cigar factory, retail businesses, and restaurants. The corner is now home to the restaurant One Federal. The above photograph shows some of the foundry employees. To the right in the photograph below is a glimpse of the balcony of the St. Albans House.

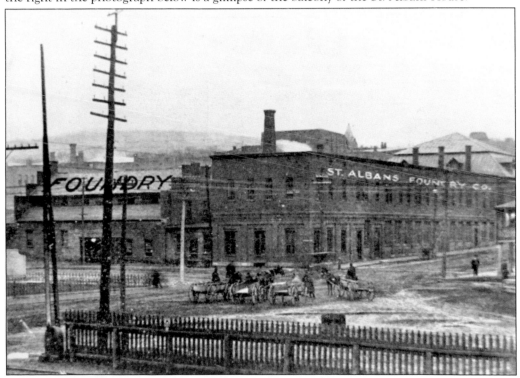

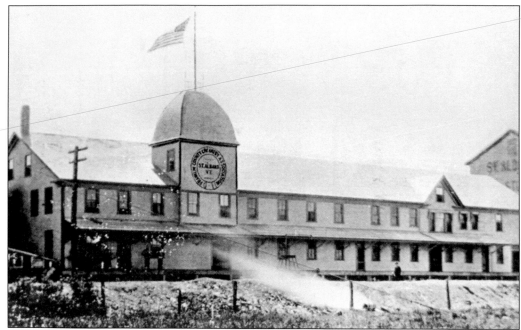

The Franklin County Creamery Association was organized in 1890 as a consolidation of small creameries in Franklin County. It produced 10 tons of golden butter a day in the busy season. The butter was mainly sold in New England, but it was used the world over. The greatest testimonial to the creamery was that supply never equaled demand. The greater part of the equipment of the mechanical department was furnished by the St. Albans Foundry. The creamery building in the above photograph boasted a complete suite of living apartments for the employees, among other state-of-the-art appointments. Among the creamery officers was J. Gregory Smith, president. The photograph below depicts a display of the St. Albans butter at the Food and Health Exposition in Boston. This structure burned, and the current St. Albans Cooperative Creamery now stands on Deal Street.

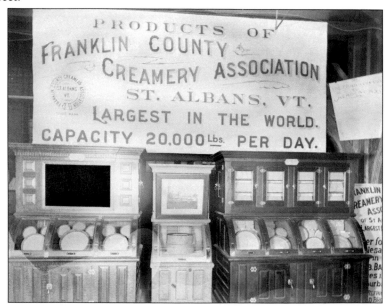

The Bostwick Brothers Coal and Lumber Company was founded by Israel Bostwick in 1870. Located at the foot of Kingman Street, this 1905 photograph shows Bostwick and his sons, Milton and Cornelius, in front of their building. The company specialized in five different types of coal from Lackawanna to blacksmith's coal. Its lumber products include shingles, doors, sash, and blinds. In addition, the Bostwicks sold brick, lime, cement, and prepared mortar.

George W. Lepper Cash Store is shown here in the 1880s. The two-story building was located on the southwest corner of South Main Street and Lower Welden and contained the store on the first floor and living quarters on the second. Its location was attractive because of traffic on the main thoroughfare of the city. Pictured in the foreground is a flashy team of white horses, their teamster, and a fire hose wagon at rest. Over time, the site of Lepper's store was occupied by Bray's Market, and today on this site is a large apartment building.

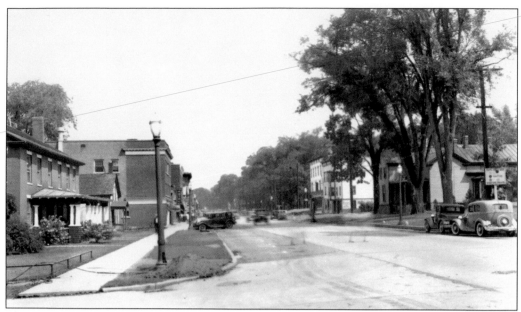

There are several interesting details revealed by this photograph of Main Street looking north from the corner of Stebbins Street in the mid-1930s. The house on the left was demolished to make way for the new federal building and post office. Its porch was removed and added to a brick house on Route 7 North, near the turn to Country Club Estates. The Spencer Hotel became Hotel Kelley and now houses Kevin Smith's Sports Shop. Note the sign on the right with instructions for the new electric traffic lights at Fairfield, Main, and Lake Streets.

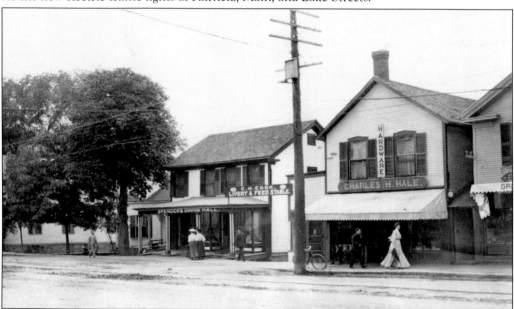

This photograph offers a view of South Main Street at the foot of Fairfield Street around 1910. This area housed a number of businesses over the years, including small markets, a candy store, restaurants, and fuel companies. In more modern times, Sweeney's Hardware and Ann's Bakery were located in the Holmes Block. Notice the sign for the C. H. Cook Livery and Feed Stable and the bicycle leaning against the utility pole. Today Hale Hardware is home to Mimmo's.

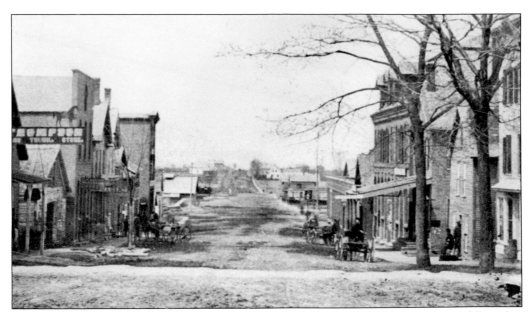

This c. 1870 photograph shows a rather sparsely settled Lake Street looking west toward Foundry, now Federal, Street. The buildings in the foreground contain a blend of commercial and residential spaces. Thompson's trunk store with its horse above seems a fitting business for the horse-drawn days. At street level, a couple of residents are taking in the day from their doorway. In the distance is a unique view of a city whose development is in its infancy.

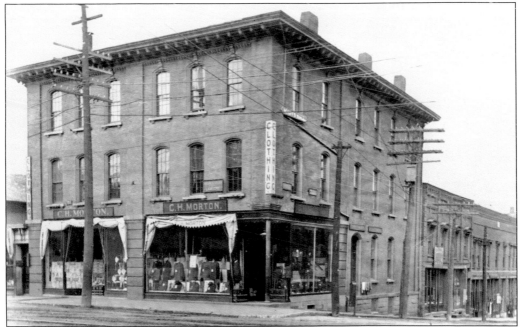

C. H. Morton's clothing house was founded by his father, H. G. Morton, in 1868. This photograph shows Morton's in the 1930s, located on the southwest corner of Lake and Main Streets. It advertised "Gents' Furnishings, Trunks and Valises," and, in addition, billed itself to be the "largest and best clothing and gentlemen's furnishing goods store in the state." At this time, the tracks of the St. Albans Street Railway Company can be seen. Today the same site is the Rail City Market.

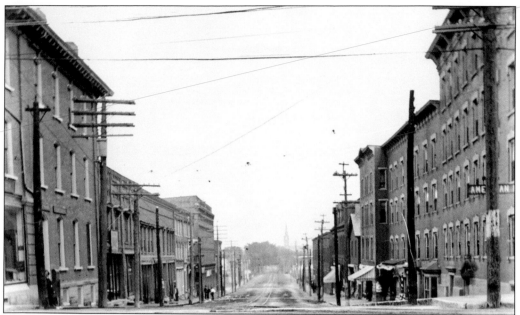

Dated September 1906, this view of Lake Street shows the trolley tracks heading towards St. Albans Bay with the spire of Holy Angels in the background. To the right is a sign for the American House and to the left Morton's Clothing Store. By the side of Morton's, two gentlemen appear to be posting their letters into a mail drop. The next building on the left, with the elephant sign, was possibly Prosper Michaud's shoe store.

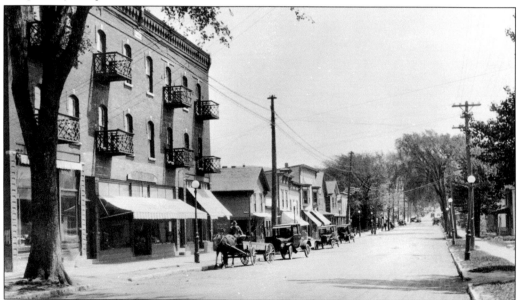

This photograph, taken around 1915, shows Guay's Market on lower Lake Street near the intersection of Elm Street. The signature stone at the top of the structure reads "Desloges 1900." Quality meats ere available from expert meat cutters Augustin Guay and his son, Bernard. Dolores Guay's akeshop was in the west side of the store. This building, now owned by Mark Lareau, houses is appraisal business and the Salvation Army Thrift Store. There are apartments on the upper oors. Looking east up the street, notice the Chevrolet sign.

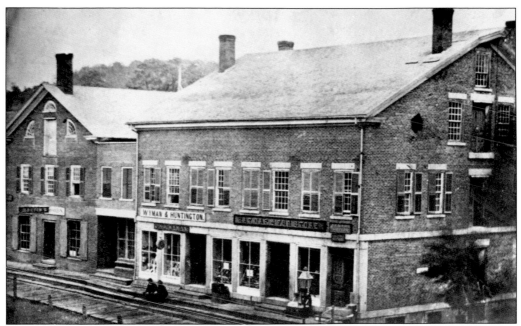

The east side of Main Street north of Taylor Park was developed early on with a variety of businesses. These two images show the Brainerd Block at the corner of Bank and Main Streets about 20 years apart. The corner building in the above photograph, taken around 1860, was remodeled extensively, resulting in its appearance in the image below, which was taken around 1880. Charles Wyman's jewelry store is visible in both pictures, as is the corner lamppost. Note the tiered boardwalk and the functioning shutters in the above picture. Below shows a still unpaved Main Street and a farther view north. Note the apothecary sign in front of Dutcher's Drug Store. Miss Beattie's hat shop, just north of Dutcher's, was the site of the only fatality during the St. Albans Raid. In the center, a sign for the *St. Albans Advertiser* can be seen. This weekly newspaper was published on Fridays.

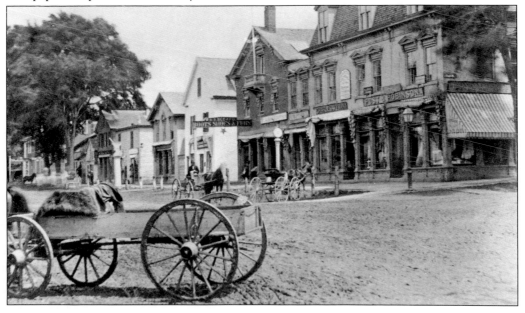

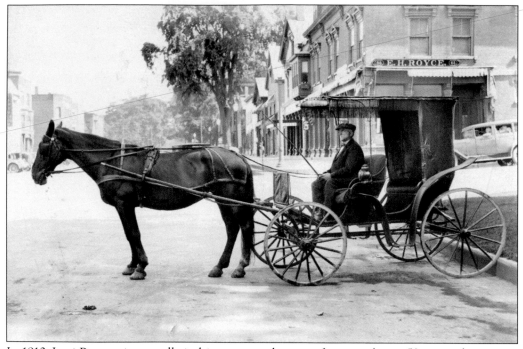

In 1910, Levi Perron sits proudly in his two-seated surrey after completing 50 years of service as a hack man. Of the original 17 charter members, he was the last remaining hack in St. Albans. His parking stand was on the north side of Taylor Park. Orders were also relayed at Dutcher's Drug Store by raising a white flag to summon him. During mud season, he came to the aid of the many people stuck in mud.

On North Main Street in 1841, Luther Loomis Dutcher began what was to become the Dutcher dynasty. Frederick Nelson Dutcher was the owner of the drugstore when it closed in 1961 after 120 years, although he remained a pharmacist for several more years. The main ingredient of its famous product, Dutcher's Lightning Fly Killer, was arsenic and 20 people were needed to produce the product to keep up with the demand. In 1892, it became known as the Frederick Dutcher Drug Company.

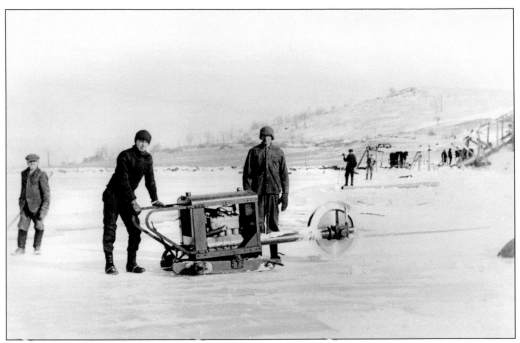

Ice harvesting reached its peak in the late 1800s. In 1886, twenty-five million tons of ice were harvested in New England; by 1920, the number had dropped to 15 million. The Fisher Ice Company, founded in the 1930s, harvested, stored, and delivered ice in St. Albans. It was located on the flat between Aldis and French Hills, now Interstate 89. Harvesting involved several steps. A horse-drawn scraper removed the snow from the ice, and then a horse-drawn marker cut the ice into 22-by-30-inch blocks. Finally the blocks were cut and floated to the icehouse, carried inside by elevators, stacked, and covered with sawdust. The above photograph depicts the hand-operated cutter. At the back left, notice the elevator, which ferried the blocks to the storage shed seen below.

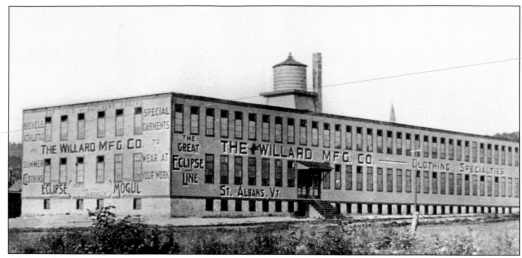

The Willard Manufacturing Company opened in 1886 and produced duck trousers and women's skirts. By 1896, its growing popularity and sales necessitated new and larger quarters. The mammoth factory on the corner of Stowell and Allen Streets was the largest factory of its kind in the world and, at its peak, employed 300 people. It had its own electric light and power plant, and direct motors operated all machinery. Its product line included auto coats, sailor suits, shooting coats, baseball suits, and summer uniforms for the U.S. Army and Navy. The Willard closed in early 1920, was later purchased by Leader Evaporator, and now contains subsidized housing.

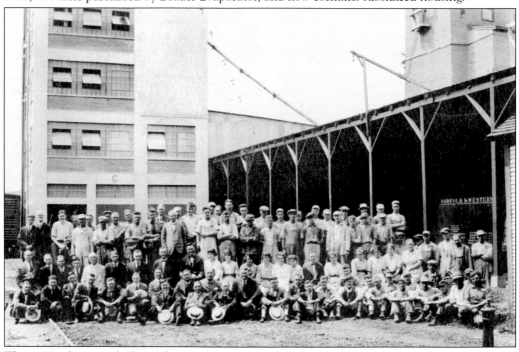

The 1920s photograph shows the 100-plus employees of the St. Albans Grain Company, founded in 1903. The company's two-story warehouse was 400 feet long, 30 feet wide, and contained a 65-foot-high elevator whose bin capacity was 25,000 bushels of bulk grain. Use of the elevator required only 45 minutes to unload and weigh a carload of grain. St. Albans Grain later produced under the Wirthmore label, and in 1967, the parent company closed it down.

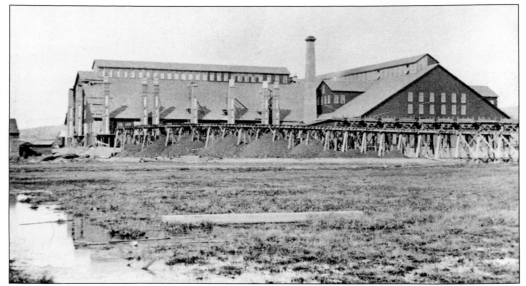

Southwest of the Lake Street railroad station between Lower Welden Street and Stevens Brook was the St. Albans Iron and Steelworks, which began manufacturing steel in 1878. Known as the rolling mill, it produced rails for the local railroads. The concern produced one-fourth of its needs, importing the remainder from the British Isles. By 1888, under the management of Aldis O. Brainerd, the company employed 175 men with an output of 20,000 tons of rails per year.

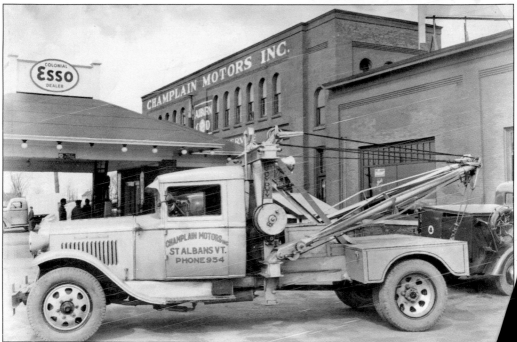

Built in 1901 at 281 North Main Street, this building was originally used by the St. Albans S[t.] Railway as its headquarters and carbarn. Champlain Motors, Inc., was established in 1909 used this building for many years. Their General Motors truck (center stage in the photo advertises its business, along with a three-digit telephone number, and a Ma Bell truck st the right. The *St. Albans Messenger* currently occupies this building.

Discover Thousands of Local History Books
Featuring Millions of Vintage Images

Arcadia Publishing, the leading local history publisher in the United States, is committed to making history accessible and meaningful through publishing books that celebrate and preserve the heritage of America's people and places.

Find more books like this at
www.arcadiapublishing.com

Search for your hometown history, your old stomping grounds, and even your favorite sports team.

ADQ-2129 4/1

RG
133.5
M48
1997

Index

◌

22. Goldfard and Greif, *The No-Hysterectomy Option*, 125.

23. Other current reasons for recommending a hysterectomy include pelvic inflammatory disease, cysts, pelvic pain, and premenstrual syndrome.

24. Ivan K. Strausz, *You Don't Need a Hysterectomy: New and Effective Ways of Avoiding Major Surgery* (New York: Addison-Wesley, 1993), 52–56.

25. See Strausz, *You Don't Need a Hysterectomy*, 52–56 for more details.

26. West and Dranov, *The Hysterectomy Hoax*, 48.

27. The West also has a high rate of hysterectomies.

2. David Brown, "20–Year Rise in Caesarean Deliveries Appears to Have Stopped," *Washington Post,* 19 May 1994, final edition.

3. Suzanne Arms, *Immaculate Deception II: A Fresh Look at Childbirth* (Berkeley: Celestial Arts, 1994), 91.

4. Arms, *Immaculate Deception II,* 91.

5. Eisenberg, Murkoff, and Hathaway, "*What to Expect,*" 245–46.

6. Brown, "20-Year Rise."

7. Arms, *Immaculate Deception II,* 93.

8. Martha Shirk, "C-Section Rate Differs Widely According to Income, Race," *St. Louis Post-Dispatch,* 10 September 1993, 5 star edition.

9. Pieter E. Treffers and Maria Pel, "The Rising Trend for Caesarean Birth," *British Medical Journal* 307 (October 1993): 1017.

10. Arms, *Immaculate Deception II,* 163.

11. Randall S. Stafford, "The Impact of Non-Clinical Factors on Repeat Cesarean Section," *Journal of the American Medical Association* 265 (1991): 59–63.

12. "Illinois Blues Report Dip in Rate of C-Sections," *Modern Healthcare,* 12 November 1990, news digest section.

13. Robert McCabe, "Cigna Plan Limits Stay for Delivery," *Fort Lauderdale Sun-Sentinel,* 26 August 1993, Business section.

14. Alison Macfarlane and Geoffrey Chamberlaine, "What Is Happening to Caesarean Rates?" *Lancet* 341 (October 1993): 1005.

15. Treffers and Pel, "The Rising Trend."

16. Florida *Statutes* (1993), sec. 383.336.

17. Lisa C. Ikemoto, "The Code of Perfect Pregnancy: At the Intersection of the Ideology of Motherhood, the Practice of Defaulting to Science, and the Interventionist Mindset of Law," *Ohio State Law Journal* 53 (1992): 1243.

18. Herbert A. Goldfarb and Judith Greif, *The No-Hysterectomy Option: Your Body—Your Choice* (New York: John Wiley and Sons, 1990), 134–35.

19. "Unnecessary Hysterectomy: The Controversy That Will Not Die," *HealthFacts* 18 (July 1993): 2.

20. Stanley West and Paula Dranov, *The Hysterectomy Hoax* (New York: Doubleday, 1994), 1.

21. West and Dranov, *The Hysterectomy Hoax,* 18.

42. Etienne-Emile Baulieu, The *"Abortion Pill"*: *RU-486 A Woman's Choice* (New York: Simon and Schuster, 1990), 109.

43. Susan Headden, "The 'Abortion-Pill' Wars," *New Woman,* October 1992, 119.

44. *Federal Food, Drug and Cosmetic Act of 1938, U.S. Code,* vol. 21, sec. 301–1509 (1988).

45. For a complete review of the FDA approval process, see Kari Hanson, "Approval of RU-486 as a Postcoital Contraceptive," *University of Puget Sound Law Review* 17 (1993): 163–89.

46. Baulieu, *Abortion Pill,* 108.

47. "FDA Clearing Way for French Abortion Pill," *San Francisco Chronicle,* 17 December 1992, final edition.

48. The Population Council has also sponsored other controversial contraceptives, such as Norplant and IUDs.

49. Renate Klein, Janice G. Raymond, and Lynette J. Dumble, *RU 486: Misconceptions, Myths and Morals* (North Melbourne, Australia: Spinifex Press, 1991). Of related interest by the same author: Janice G. Raymond, *Women as Wombs: Reproductive Technology and the Battle over Women's Freedom* (San Francisco: Harper, 1993).

50. Harold M. Silverman, ed., *The Pill Book* (New York: Bantam Books, 1994), 566–68.

51. "Low-Cost Alternative to RU-486 Abortion Pill Being Studied," *Los Angeles Times,* 20 October 1993, home edition.

52. Carol Jouzaitis, "Doctor's Abortion-Drug Technique Draws Fire," *Chicago Tribune,* 12 September 1994, North, sports final edition.

53. "Abortion Pill May Battle Brain Tumors; RU486 Used to Fight Meningioma," *Science News* 143 (1993): 255.

54. Pam Lambert, "The Killing Field," *People,* 16 January 1995, 40–43.

55. Rone Tempest, "A French Option on Abortion," *Los Angeles Times,* 11 August 1990, home edition.

NOTES TO CHAPTER SIX

1. Arlene Eisenberg, Heidi E. Murkoff, and Sandee E. Hathaway, *What to Expect When You're Expecting* (New York: Workman Publishing, 1991), 243.

30. *National Organization for Women v. Scheider*, 62 USLW 4073 (1994).

31. " 'Jane Roe' Joins Anti-Abortion Group," *New York Times*, 11 August 1995.

32. For extensive discussion of the repercussions, see John A. Robertson, "In the Beginning: The Legal Status of Early Embryos," *Virginia Law Review* 76 (1990): 487–91.

33. Also referred to as RU486 and RU 486. Since Roussel-Uclaf signed their rights over to the population council, the drug will be known as mifepristone, rather than RU-486, in the United States.

34. It limits the mobility of sperm, thereby making fertilization less likely.

35. Also known as the Yuzpe method.

36. In a recently published study, the pregnancy rate for RU-486 as a "morning after" pill was significantly lower than for Ovral. Anne M.C. Webb, Jean Russell, and Max Elstein, "Comparison of Yuzpe Regimen, Danazol, and Mifepristone RU486 in Oral Postcoital Contraception," *British Medical Journal* 305 (October 1992): 927. The results of another study comparing RU-486 and Ovral as postcoital contraceptives indicated that RU-486 was more effective, although the differences were not striking. Anna Glasier, K.J. Thong, Maria Dewar, May Mackie, and David T. Baird, "Mifepristone (RU 486) Compared with High-Dose Estrogen and Progestogen for Emergency Postcoital Contraception," *New England Journal of Medicine* 327 (October 1992): 1041–44.

37. Webb, Russell, and Elstein, "Comparison of Yuzpe" and Glasier et al., "Mifepristone (RU 486)."

38. Don Colburn, "A Morning-After Pill: New Study Says RU-486 Works Better than Current Methods," *Washington Post*, 13 October 1992, final edition.

39. In some cases it is used up until the ninth week of pregnancy.

40. It is believed that the one fatality that resulted from RU-486 may have been related to the injection of a concentrated dosage of synthetic prostaglandins.

41. Without synthetic prostaglandin, the success rate ranges from 60 to 85 percent. O.M. Avrech, A. Golan, Z. Weinraub, I. Bukovsky, and E. Caspi, "Mifepristone (RU486) Alone or in Combination with a Prostaglandin Analogue for Termination of Early Pregnancy: A Review," *Fertility and Sterility* 56 (September 1991): 385–93.

6. *Griswold v. Connecticut,* 381 US 479 (1965).

7. *Eisenstadt v. Baird,* 405 US 438 (1972).

8. *Roe v. Wade,* 410 US 113 (1973).

9. *Roe v. Wade,* 113.

10. The four Missouri cases are *Planned Parenthood v. Danforth,* 428 US 52 (1976); *Poelker v. Doe,* 432 US 519 (1977); *Planned Parenthood v. Ashcroft,* 462 US 476 (1983); and *Webster v. Reproductive Health Services,* 492 US 490 (1989). The Pennsylvania cases are *Beal v. Doe,* 432 US 438 (1977); *Colautti v. Franklin,* 439 US 379 (1979); *Thornburgh v. American College,* 476 US 747 (1986); and *Planned Parenthood v. Casey,* 505 US 833 (1992).

11. *Akron v. Akron Center,* 462 US 416 (1983).

12. *Planned Parenthood v. Casey,* 833.

13. Lacayo, "The Future," 27.

14. *Planned Parenthood v. Danforth,* 52; *Akron v. Akron Center,* 416; and *Bellotti v. Baird,* 443 US 662 (1979).

15. *Planned Parenthood v. Danforth,* 52.

16. *Planned Parenthood v. Ashcroft,* 476; *Planned Parenthood v. Casey;* and *Ohio v. Akron Center for Reproductive Health,* 497 US 502.

17. *Abortion Denied: Shattering Young Women's Lives,* Feminist Majority Foundation, 1990, videocassette.

18. *Hodgson v. Minnesota* (1990), 497 US 417.

19. *Colautti v. Franklin,* 379.

20. *Webster v. Reproductive Health Services,* 490 and *Thornburgh v. American College,* 747.

21. *Planned Parenthood v. Danforth,* 52 and *Planned Parenthood v. Casey,* 833.

22. *Akron v. Akron Center,* 416 and *Planned Parenthood v. Ashcroft,* 476.

23. *Simopoulos v. Virginia,* 462 US 506 (1983).

24. *Beal v. Doe,* 432 US 438 (1977) and *Maher v. Roe,* 432 US 464 (1977).

25. *Poelker v. Doe,* 432 US 519 (1977).

26. *Webster v. Reproductive Health Services,* 490.

27. *Rust v. Sullivan,* 500 US 173 (1991).

28. *Webster v. Reproductive Health Services,* 490.

29. *Bray v. Alexandria Women's Health Clinic,* 506 US 263 (1993).

36. Marco Quazzo, "Electromagnetic Fields and Defect Claims: Will Manufacturers Be Liable for Personal Injuries?" *Computer Lawyer* 11 (March 1994): 21.

37. *Hayes v. Raytheon,* no. 92-40004 7th (1993) as cited in Quazzo, "Electromagnetic Fields and Defect Claims," 3.

38. Lawrence Chesler, "Repetitive Motion Injury and Cumulative Trauma Disorder: Can the Wave of Products Liability Litigation Be Averted?" *Computer Lawyer* 9 (February 1992): 13.

39. John Gliedman, "Magnetic Fields and Cancer: Should You Be Concerned?" *Computer Shopper* 13 (January 1993): 862.

40. Louise Kehoe, "The Friends That May Also Be Foes," *Financial Times Limited,* 8 December 1989, sec. 1.

41. Albert Gore, as cited in Kehoe, "The Friends."

42. Teresa M. Schnorr of NIOSH, as cited in Susan Okie, "No Link Found between VDTs, Miscarriages," *Washington Post,* 14 March 1991, final edition.

NOTES TO CHAPTER FIVE

1. "Total public dollars spent for contraceptive services fell by one-third between 1980 and 1990." *WAC STATS: The Facts about Women* (New York: New Press, 1993), 1.

2. Maureen Harrison and Steve Gilbert, eds., *Abortion Decisions of the United States Supreme Court: The 1970's* (Beverly Hills: Excellent Books, 1993); Maureen Harrison and Steve Gilbert, eds., *Abortion Decisions of the United States Supreme Court: The 1980's* (Beverly Hills: Excellent Books, 1993); Maureen Harrison and Steve Gilbert, eds., *Abortion Decisions of the United States Supreme Court: The 1990's* (Beverly Hills: Excellent Books, 1993).

3. Richard Lacayo, "Abortion: The Future Is Already Here," *Time,* 4 May 1992, 27.

4. For a fascinating history of contraceptives and abortion, see Kirtsi A. Dyer, "Curiosities of Contraception: A Historical Perspective," *Journal of the American Medical Association* 264 (December 1990): 2818.

5. Mary Becker, Cynthia Grant Bowman, and Morrison Torrey, *Feminist Jurisprudence: Taking Women Seriously* (St. Paul: West Publishing, 1994), 368.

20. A prospective study was proposed sometime in the 1980s by physicians at Mount Sinai School of Medicine, an industrial health research facility. The results have not been published as of yet. Peter H. Lewis, "Personal Computers: Questions on Health and PC's," *New York Times*, 5 July 1988, late city final edition.

21. As early as 1984 a safeguard bill was introduced into the House Labor and Commerce Committee. "VDT Safeguard Bill Stalled in House Committee," *Proprietary to United Press International*, 25 April 1984, A.M. cycle.

22. "Judge Overturns San Francisco VDT Law," *Chicago Tribune*, 14 February 1992, sec. 1.

23. Rhode Island *General Laws* (1993), secs. 28-20-2.1.

24. Maine *Revised Statutes* (1993), sec. 252.

25. Connecticut *Annotated Law Statutes* (1993), sec. 228.

26. Mark A. Pinsky, "VDT Radiation," *Nation*, January 1989, 41.

27. Eric Schmitt, "Businesses Assess Impact of Law on Video Terminals," *New York Times*, 19 June 1988, late city final edition. This is especially true with the new North Atlantic Free Trade Agreement (NAFTA).

28. Michael Powell, "VDT Workers Get Some Relief in City's Contract Agreement," *Newsday*, 26 June 1990, city edition.

29. Kevin G. Hall, "SSA, AFGE Sign Three-Year Pact," *Proprietary to United Press International*, 25 January 1990, British Columbia cycle.

30. Paul Saffo, "The Threat of Electromagnetic Fields: Are Our Computers Killing Us?" *PC Computing* 5 (December 1992): 126.

31. David Kirkpatrick, "Do Cellular Phones Cause Cancer?" *Fortune*, March 1993, 82.

32. Saffo, "The Threat of Magnetic Fields," 126.

33. *Factories and Commercial Premises Act, New Zealand Code* (1981), as noted in the *Code of Practice* of the Industrial Welfare Division of the Department of Labour.

34. See, for example, Peter H. Lewis, "The Executive Computer: Are Computer Safety Laws Taking the Right Tack?" *New York Times*, 6 January 1991, late edition.

35. Arthur Goldgaber, "Business Fears Unwieldy Imposition of New Municipal Laws Covering Video Terminal Use," *Los Angeles Business Journal* 13 (February 1991): 7.

with Video Display Terminals, and Course of Pregnancy," *Scandinavian Journal of Work, Environment and Health* 14 (1988): 293.

10. Heather E. Bryant and Edgar J. Love, "Video Display Terminal Use and Spontaneous Abortion Risk," *International Journal of Epidemiology* 18 (1989): 132.

11. Gayle C. Windham, Laura Fenster, Shanna H. Swan, and Raymond R. Neutra, "Use of Video Display Terminals during Pregnancy and the Risk of Spontaneous Abortion, Low Birthweight, or Intrauterine Growth Retardation," *American Journal of Industrial Medicine* 18 (1990): 675.

12. Lars P. A. Brandt and Claus V. Nielsen, "Congenital Malformations among Children of Women Working with Video Display Terminals," *Scandinavian Journal of Work, Environment and Health* 16 (1990): 329.

13. Claus V. Nielsen and Lars P. A. Brandt, "Spontaneous Abortion among Women Working with Video Display Terminals," *Scandinavian Journal of Work, Environment and Health* 16 (1990): 323.

14. Eve Roman, Valerie Beral, Margo Pelerin, and Carol Hermon, "Spontaneous Abortion and Work with Visual Display Units," *British Journal of Industrial Medicine* 49 (1992): 507.

15. Teresa M. Schnorr, Barbara A. Grajewski, Richard W. Hornung, Michael J. Thun, Grace M. Egeland, William E. Murray, David L. Conover, and William E. Halperin, "Video Display Terminals and the Risk of Spontaneous Abortion," *New England Journal of Medicine* 324 (March 1991): 727.

16. Marjorie Sun, "Federal VDT Study Finally Wins Approval," *Science* 232 (June 1986): 1594.

17. Bureau of National Affairs, Inc., "OMB Decision Allows VDT Study, but NIOSH is Wary of Requirements," *Government Employees Relations Report* 24 (June 1986): 846.

18. Laurie Garrett, "VDTs, Miscarriage Not Linked: U.S. Study Greeted with Relief, but Critics Decry Limited Scope," *Newsday*, March 1991.

19. Marja-Liisa Lindbohm, Maila Hietanen, Pentti Kyyronen, Markku Sallmen, Patrick von Nandelstadh, Helena Taskinen, Matti Pekkarinen, Matti Ylikoski, and Kari Hemminki, "Magnetic Fields of Video Display Terminals and Spontaneous Abortion," *American Journal of Epidemiology* 136 (November 1992): 1041.

24. Judy Howard, "Chronic Drug Users as Parents," *Hastings Law Journal* 43 (March 1992): 651–52.

25. Wendy Chavkin, "Drug Addiction and Pregnancy: Policy Crossroads," *American Journal of Public Health* 80 (1990): 485.

26. Stephen R. Kandall and Wendy Chavkin, "Illicit Drugs in America: History, Impact on Women and Infants, and Treatment Strategies for Women," *Hastings Law Journal* 43 (March 1992): 642.

27. Judy Licht, "Pregnant Addicts: A Call for Treatment, Not Punishment," *Washington Post,* 29 June 1993, final edition.

28. Kate Bagley and Alida V. Merlo, "Controlling Women's Bodies," in Alida V. Merlo and Joycelyn M. Polleck, *Women, Law and Social Control* (Needham Heights, MA: Allyn and Bacon, 1995), 136.

29. Licht, "Pregnant Addicts."

30. Spencer, "Prosecutorial Immunity."

NOTES TO CHAPTER FOUR

1. *International Union, United Automobile, Aerospace and Agricultural Implement Workers of America, UAW, et al. v. Johnson Controls, Inc.,* 111 Sup. Ct. 1196 (1991).

2. *Title VII of the Civil Rights Act of 1964,* as amended, *U.S. Code,* vol. 42, sec. 2000e et seq (1990).

3. *Pregnancy Discrimination Act of 1978, U.S. Code,* vol. 42, 92 Stat. 2076, sec. 2000e(k).

4. "Miscarriages and Computer Terminals," *Doctor's People Newsletter* 3 (March 1990): 1.

5. "Miscarriages and Computer Terminals," 1.

6. "Miscarriages and Computer Terminals," 1.

7. However, a thorough review can be found in Rosalind S. Bramwell and Marilyn J. Davidson, "A Review of Current Evidence concerning Possible Reproductive Hazard from VDUs," *Journal of Reproductive and Infant Psychology* 10 (1992): 3.

8. Marilyn K. Goldhaber, Michael R. Polen, and Robert A. Hiatt, "The Risk of Miscarriage and Birth Defects among Women Who Use Visual Display Terminals during Pregnancy," *American Journal of Industrial Medicine* 13 (1988): 695.

9. Tuula Nurminen and Kari Kurppa, "Office Employment, Work

3. Peak and Del Papa, "Criminal Justice."

4. James L. Mills, Lewis B. Holmes, Jerome H. Aarons, Joe Leigh Simpson, Zane A. Brown, Lois G. Jovanovic-Peterson, Mary R. Conley, Barry I. Graubard, Robert H. Knopp, and Boyd E. Metzger, "Moderate Caffeine Use and the Risk of Spontaneous Abortion and Intrauterine Growth Retardation," *Journal of the American Medical Association* 269 (1993): 593.

5. Mills et al., "Moderate Caffeine."

6. Arlene Eisenberg, Heidi E. Murkoff, and Sandee E. Hathaway, *What to Expect When You're Expecting* (New York: Workman Publishing, 1991).

7. Eisenberg, Murkoff, and Hathaway, *What to Expect*, 60.

8. Eisenberg, Murkoff, and Hathaway, *What to Expect*, 60.

9. Eisenberg, Murkoff, and Hathaway, *What to Expect*, 56.

10. Peak and Del Papa, "Criminal Justice," 249.

11. Peak and Del Papa, "Criminal Justice," 250.

12. Peak and Del Papa, "Criminal Justice," 249.

13. With the exception of the amphetamine derivatives of hallucinogens.

14. Peak and Del Papa, "Criminal Justice," 248.

15. Lisa C. Ikemoto, "The Code of Perfect Pregnancy: At the Intersection of the Ideology of Motherhood, the Practice of Defaulting to Science, and the Interventionist Mindset of Law," *Ohio State Law Journal* 53 (1992): 1266.

16. There were other provisions as well, such as requiring Johnson to complete a high school equivalency test.

17. Ikemoto, "Perfect Pregnancy," 1268.

18. *In re Valerie D.*, 613 A 2d 748 (Conn. 1992).

19. David C. Blickenstaff, "Defining the Boundaries of Personal Privacy: Is There a Paternal Interest in Compelling Therapeutic Fetal Surgery?" *Northwestern University Law Review* 88 (1994): 1168.

20. Blickenstaff, "Defining Boundaries," 1169.

21. Blickenstaff, "Defining Boundaries."

22. Susan Stefan, "Whose Egg Is It Anyway?: Reproductive Rights of Incarcerated, Institutionalized and Incompetent Women," *Nova Law Review* 13 (1989): 442.

23. Margaret P. Spencer, "Prosecutorial Immunity: The Response to Prenatal Drug Use," *Connecticut Law Review* 25 (1993): 406.

Larry Gostin, ed., *Surrogate Motherhood: Politics and Privacy* (Bloomington: Indiana University Press, 1990), 44.

47. For an extensive discussion of national and international legislation and case law, see Diederika Pretorius, *Surrogate Motherhood: A Worldwide View of the Issues* (Springfield: Charles C. Thomas, 1994).

48. Field, *Surrogate Motherhood,* 1.

49. Field, *Surrogate Motherhood,* 1–2.

50. Phyllis Chesler, "Mothers on Trial: Custody and the 'Baby M' Case," in Dorchen Leidholdt and Janice G. Raymond, eds., *The Sexual Liberals and the Attack on Feminism* (New York: Pergamon Press, 1990), 95–102.

51. *Johnson v. Calvert,* 851 P 2d 776 (1993).

52. Davan Maharaj, "Orange County Focus: Santa Ana; Surrogate Mother, Couple Drop Suits," *Los Angeles Times,* 22 June 1994, Metro section.

53. Pretorius, *Worldwide View,* 57.

54. Complete copies of all of these guidelines are included in Larry Gostin, ed., *Surrogate Motherhood: Politics and Privacy* (Bloomington: Indiana University Press, 1990), appendix 4.

55. Hilde L. Nelson, "Held to a Higher Standard," *Hastings Center Report* 21 (May 1991): 2.

56. Diane Burch, "Surrogacy Spawns a New Wave of Litigation: After Baby M, Legal Issues Get More Complex (and Perhaps More Costly)," *Legal Times,* 29 January 1990.

57. Annas, "Fairy Tales," 44.

58. Lori B. Andrews, "Surrogate Motherhood: The Challenge for Feminists," in Gostin, *Surrogate Motherhood,* 167.

59. Elizabeth Bartholet, *Family Bonds: Adoption and the Politics of Parenting* (Boston: Houghton Mifflin, 1993).

60. Field, *Surrogate Motherhood,* 61–69.

NOTES TO CHAPTER THREE

1. "Two Cocktail Servers Fired for Lecturing Pregnant Patron," *Chicago Tribune,* April 1991.

2. Ken Peak and Frankie Sue Del Papa, "Criminal Justice Enters the Womb: Enforcing the 'Right' to Be Born Drug-Free," *Journal of Criminal Justice* 21 (1993): 245.

29. As cited in Boseley, "Go to Work."

30. Marian D. Damewood, *The Johns Hopkins Handbook of In Vitro Fertilization and Assisted Reproductive Technologies* (Boston: Little, Brown and Company, 1990), 54.

31. Stephenson and Wagner, *Tough Choices,* 10.

32. Joseph Palca, "A Word to the Wise; On the Approval of In Vitro Fertilization Research," *Hastings Center Report* 24 (March 1994): 5.

33. Palca, "Word to the Wise."

34. "They Are the Egg Men," *Economist,* 3 September 1994, Business, Finance, and Science section.

35. Numerous individual and class action suits have been filed against insurance companies for their failure to provide IVF coverage.

36. Sarah Grady, "Brother Born Three Years after Sisters," *Associated Newspapers,* 29 July 1994, evening standard.

37. "Australia: Frozen Embryo Numbers Up," *Reuter Textline* (Melbourne), 3 February 1994.

38. Delthia Ricks, "Frozen Embryo Technique Posts Low Pregnancy Rate," *Orlando Sentinel Tribune,* 25 May 1990, 3 star edition.

39. In some states this is not an issue. For example, Missouri law declares that life begins at conception, and in Louisiana a frozen embryo is considered viable.

40. *Davis v. Davis,* 842 SW 2d 588 (1992).

41. For an extensive discussion of the legality of alternative directives, see John A. Robertson, "Prior Agreements for Disposition of Frozen Embryos," *Ohio State Law Journal* 51 (1990): 407–24.

42. Emma Tom, "Australia: Mother's Dilemma over Frozen Embryos," *Reuter Textline* (Melbourne), 19 June 1993.

43. For an extensive discussion of regulations, see Robert J. Muller, "*Davis v. Davis:* The Applicability of Privacy and Property Rights to The Disposition of Frozen Preembryos in Intrafamilial Disputes," *University of Toledo Law Review* 24 (1993): 763–804.

44. "Wombs for rent" has become a derogatory phrase to refer to surrogacy.

45. Martha A. Field, *Surrogate Motherhood* (Cambridge: Harvard University Press, 1988), 5.

46. George J. Annas, "Fairy Tales Surrogate Mothers Tell," in

11. Rowland, *Living Laboratories*, 40.

12. Niels E. Skakkebaek, Aleksander Giwercman, and David de Kretser, "Pathogenesis and Management of Male Infertility: Review Article," *Lancet* 343 (June 1994): 1473.

13. Joseph B. Verrengia, "Hatching Hope for the Infertile," *Rocky Mountain News* (Denver), 10 January 1994, Local section.

14. Brendan Pereira, "Cheaper, Less Stressful IVF Method Introduced," *Straits Times*, 15 September 1993, Home section.

15. Richard Saltus, "Technique May Treat Severe Male Infertility," *Boston Globe*, 20 April 1994, city edition.

16. Daniel Q. Haney, "What Cost Test-Tube Baby? $72,000," *Associated Press*, 28 July 1994, P.M. cycle.

17. Haney, "What Cost."

18. Robert M. L. Winston and Alan H. Handyside, "New Challenges in Human In Vitro Fertilization: Scientific and Ethical Difficulties," *Science* 260 (May 1993): 932.

19. Rowland, *Living Laboratories*, 66.

20. Lorraine Fraser, "These Little Boys Are Happy, Adored and Cherished. But Three of Their Brothers and Sisters Died so They Could Have Life," *Associated Newspapers*, 7 November 1993.

21. "Dangers to Test-Tube Babies Totally Ignored," *Guardian Newspapers*, 9 January 1994, News section.

22. "IVF Babies Develop Normally, Study Finds," *Washington Times*, 13 February 1994, final edition.

23. "French In Vitro Births Study Finds High Rate of Deformities," *Reuters World Service*, 30 June 1994, British Columbia cycle.

24. DES is a drug that was widely prescribed for women in the 1950s and 1960s to prevent miscarriage until it was discovered that the female offspring of women who had used the drug during pregnancy showed a tendency to develop vaginal cancer.

25. Gail Vines, "Shots in the Dark for Infertility," *New Scientist* 140 (27 November 1993): 13.

26. "Medical Malpractice In Vitro Fertilization," *New York Law Journal* (July 1993): 21.

27. "Royal Commission on New Reproductive Technologies," *Canada Newswire*, 28 April 1993, Domestic News section.

28. As cited in Sarah Boseley, "Go to Work on an Egg," *Guardian*, 17 September 1994.

72. Kowsky, "Giver of Life."

73. Abbie Jones, "Fertility Doctors Try to Egg On Donors," *Chicago Tribune,* 6 March 1994, sec. 6.

74. Mihill and Weale, "Birth Pangs."

75. Rowland, *Living Laboratories.*

76. Diana Scully, *Men Who Control Women's Health: The Miseducation of Obstetrician-Gynecologists* (New York: Teachers College Press, 1994), 40.

77. For a more thorough discussion of Sims and his medical procedures, see Scully, *"Men Who Control Women's Health,"* 40–48.

78. Aileen Ballantyne, "My Baby's Brave New World," *Times* (London), 4 January 1994.

79. Alexander Dorozynski, "France Battles Out Bioethics Bill," *British Medical Journal* 308 (January 1994): 291.

80. Dorozynski, "France Battles."

NOTES TO CHAPTER TWO

1. Susan Faludi, *Backlash: The Undeclared War against American Women* (New York: Anchor Books, 1991), 27–32.

2. Janice G. Raymond, *Women as Wombs: Reproductive Technology and the Battle over Women's Freedom* (San Francisco: Harper, 1993), 3–5.

3. Faludi, *Backlash,* 28.

4. Patricia Stephenson and Marsden G. Wagner, eds., *Tough Choices: In Vitro Fertilization and the Reproductive Technologies* (Philadelphia: Temple University Press, 1993), 3.

5. Stephenson and Wagner, *Tough Choices,* 3–4.

6. Stephenson and Wagner, *Tough Choices,* 6.

7. Stephenson and Wagner, *Tough Choices,* 6.

8. Diane M. Gianelli, "Embryo Research Could Help Many, but Is It Ethical?" *American Medical News* 37 (March 1994): 1.

9. Gianelli, "Embryo Research." The number of American babies born from IVF had risen to over twenty thousand by 1994. "New Fertility Technique for Males Offers Hope," *Orlando Sentinel,* 6 July 1994, 3 star edition.

10. Robyn Rowland, *Living Laboratories: Women and Reproductive Technologies* (Bloomington: Indiana University Press, 1992), 40.

Gordy, "Egg Donor Rejected: Problems Plague Unlicensed Center," *Newsday*, 8 May 1992, city edition.

61. David Fletcher, "Women Urged to Ignore Instant Fertility Offer," *Daily Telegraph* (London), 25 August 1994.

62. David Fletcher, "Fertility Bartering Rules Face Review," *Daily Telegraph* (London), 19 February 1994.

63. Rowland says that eggs are large cells and difficult to freeze, because ice crystals form and rupture the membrane. She also cited a successful birth from a frozen egg in 1983, but the egg had only been frozen a matter of hours. Rowland, *Living Laboratories,* 17. Recently Australian researchers claim to have developed a successful method of freezing eggs before fertilization. David Williams, "Australia Claims World First in Freezing Human Eggs," *Agence France Presse,* 19 June 1994, International News section. Since the eggs cannot, like semen, be frozen and quarantined for six months, they pose an increased risk of HIV transmission.

64. The "yuck" factor is used to refer to the distaste and skepticism of the general public regarding reproductive technological advances by the medical profession. Linda Grant, "Fifteen Years Ago, the World's First Test-Tube Baby Was Greeted with Wonder. But Now We Are Being Asked to Accept Scientific Advances That Seem Repulsive, Even Dangerous. Should Our Morality Be Determined in a Laboratory?" *Guardian*, 28 January 1994.

65. England recently voted to ban the future use of fetal eggs for this procedure. Christine Doyle, "When Donors Answer a Woman's Dream as the Controversy Over 'Designer Babies' Continues," *Daily Telegraph* (London), 26 July 1994.

66. Marilyn Elias, "Who Controls Reproductive Technology?" *USA Today*, 5 January 1994.

67. Linda Grant, "Fifteen Years Ago."

68. Abigail Trafford, "Post-Menopausal Moms Cause a Stir," *Record* (Bergen), 17 January 1994.

69. Trafford, "Post-Menopausal Moms."

70. Carol Stocker, "The Egg Donor: Helping Infertile Couples Takes Time, Dedication and Resilience," *Boston Globe,* 10 December 1991, city edition.

71. Kowsky, "Giver of Life."

teghem, "Counselling and Selection of Homosexual Couples in Fertility Treatment," *Human Reproduction* 4 (1989): 850–53.

49. Raboy, "Secrecy and Openness," 191.

50. Gianelli, "Benefits Seen," 3.

51. Gianelli, "Benefits Seen," 3.

52. Gianelli, "Benefits Seen," 3.

53. "First Test-Tube Birth Using Donated Egg," *Associated Press,* 12 January 1984, P.M. cycle. Rowland reports a birth from a donated egg in 1983, but no confirmation can be located. Robyn Rowland, *Living Laboratories* (Bloomington: Indiana University Press, 1992), 17.

54. "First 'Test Tube' Baby Conceived through Egg Donor Program," *Newswire,* 21 November 1988.

55. Melinda Beck, Mary Hager, Pat Wingert, Patricia King, Jeanne Gordon, Stanley Holmes, and Susan Miller, "How Far Should We Push Mother Nature," *Newsweek,* 17 January 1994, 54.

56. Richard Scheinin, "Why Older Moms, Fetal Eggs and 'Designer Babies' Provoke Outrage," *Dallas Morning News,* 23 January 1994, final home edition.

57. Kim Kowsky, "Giver of Life, Again and Again; 'Super-Donors' Repeatedly Undergo a Lengthy, Painful Process to Help Fertility Clinics Meet the High Demand for Eggs." *Los Angeles Times,* 3 January 1993, home edition. Under the main headline, one donor was cited as saying, "I'm proud that I can do this."

58. Rowland, *Living Laboratories,* 22.

59. For an extensive discussion of these procedures and the risks involved, see Rowland, *Living Laboratories,* 25–30.

60. However, donors are generally not fully compensated unless donation is successful. For example, one woman who could not complete the process because she developed ovarian cysts during the hormone manipulation was terminated from the egg donation program at Mount Sinai and only partially compensated. A spokesperson insisted that the hospital was not purchasing eggs but compensating only for time and inconvenience. Additionally, the donor had not signed an informed consent nor been apprised of the risks. When the donor brought her case to the attention of the media, she learned Mount Sinai was not even licensed as an egg donation clinic in the state of New York, which requires licensure of gamete donation facilities. Molly

Delaware, and Florida have similar statutory provisions. Such legislation has come under attack for being overbroad: see Michael L. Closson and Jeffrey S. Deutschman, "A Proposal to Repeal the Illinois HIV Transmission Statute," *Illinois Bar Journal* 78 (December 1990): 592–600.

36. For example, in Illinois and Delaware, negligently, recklessly, intentionally, or knowingly using semen for insemination when the donor has tested positive for HIV or other causative agents of AIDS is a felony, as is using semen for inseminations without meeting other mandatory testing requirements. See Illinois *Compiled Statutes, Annotated* (1994), sec. 20: 2310/55.46(c); Delaware *Code, Annotated* (1993), sec. 16: 2801(c). In Florida, any person who fails to test semen destined for use in inseminations is guilty of a misdemeanor. See Florida *Statutes* (1993), sec. 381.0041(11)(a).

37. Schatz, "Risky Business."

38. Schatz, "Risky Business."

39. The gene for hemophilia is carried and transmitted by females.

40. "Testing Donors of Organs, Tissues, and Semen for Antibody to Human T-Lymphotropic Virus Type III/Lymphadenopathy-Associated Virus," *Morbidity and Mortality Weekly Report* 34 (May 1985): 294. The American Medical Association endorsed the Public Health Service's recommendation in 1987.

41. "Semen Banking, Organ and Tissue Transplantation, and HIV Antibody Testing," *Journal of the American Medical Association* 259 (March 1988): 1301.

42. Diane M. Gianelli, "Benefits Seen in Regulating Fertility Medicine," *American Medical News* 35 (March 1992): 3.

43. Sharon Kirkey, "Artificial Insemination: Some Doctors Ignoring Guidelines, Says Technology Report," *Ottawa Citizen*, 20 March 1992, Valley edition.

44. Robin Schatz, "40 Sperm Donors Not Tested," *Newsday*, 15 July 1993, city edition.

45. Schatz, "40 Sperm Donors."

46. "MDs to Say Monday if Untested Sperm Used Here," *Gazette* (Montreal), 1 May 1993, final edition.

47. Rebecca Wigod, "Lesbian Couple Who Want Child Denied Sperm," *Vancouver Sun*, 22 July 1993, 2 star edition.

48. A. Brewaeys, H. Olbrechts, P. Devroey, and A.C. Van Steir-

29. For example, Indiana, Michigan, and Louisiana all require that semen be quarantined for six months and the donor tested at the time of donation and retested in six months for evidence of the HIV virus. Louisiana *Statutes* (1993), sec. 40: 1062.1(B). See also Michigan *Compiled Laws* (1992), sec. 333.20179(1) and Indiana *Statutes, Annotated* (Burns 1994), sec. 16-41-14-7(a)(1)(2).

30. For example, in Indiana, if the recipient and the donor are in a mutually monogamous relationship, the practitioner is required to perform an HIV test annually as long as insemination continues. See Indiana *Statutes, Annotated* (Burns 1994), sec. 16-41-14-7(b)(1). In Louisiana and Florida, a husband may donate semen to his wife without being subjected to any testing. See Louisiana *Revised Statutes* (1993), sec. 40: 1062.1(B)(1) and Florida *Statutes* (1993), sec. 381.0041(3)(b).

31. For example, Kentucky and Florida require physicians to warn recipients of the risk of contracting HIV. See Kentucky *Revised Statutes, Annotated* (Baldwin 1993), sec. 311.281(7); Florida *Statutes* (1993), sec. 381.0041(12).

32. For example, Delaware and Illinois require all sperm banks operating within the state to register with the Department of Health by May 1 of each year. Those failing to register are subject to a fine of five thousand dollars. See Illinois *Compiled Statutes, Annotated* (1994), sec. 20: 2310/55.46(a); Delaware *Code, Annotated* (1993), sec. 16: 2801(a).

33. In Louisiana, health facilities, physicians, or agencies that violate any provisions regarding semen specimens can be fined up to two thousand dollars. See Louisiana *Revised Statutes* (1993), sec. 40: 1062.1(E).

34. In Louisiana and Michigan, health facilities, physicians, or agencies that violate any provisions regarding semen specimens can be held liable for damages in civil actions. See Louisiana *Revised Statutes* (1993), sec. 40: 1062.1(E); Michigan *Compiled Laws* (1992), sec. 333.16273(2).

35. Tennessee *Advance Legislative Service* (1994), pub. chap. 952(2)(a)(2). Such criminal exposure to HIV is a Class C felony in Tennessee and Indiana. See Indiana *Statutes, Annotated* (Burns 1994), sec. 35-42-1-7(b). However, the offense changes to a Class A felony if it results in the transmission of HIV to any other person. Illinois,

folds," *Journal of the American Medical Association* 257 (February 1987): 1093–94; Donald E. Moore, Rhoda L. Ashley, Paul W. Zarutskie, Robert W. Coombs, Michael R. Soules, and Lawrence Corey, "Transmission of Genital Herpes by Donor Insemination," *Journal of the American Medical Association* 261 (June 1989): 3441–43; B.S. Shanis, J.H. Check, and A.F. Baker, "Transmission of Sexually Transmitted Diseases by Donor Semen," *Archives of Andrology* 23 (1989): 249–57.

26. For example, Illinois and Delaware, which have virtually identical statutory provisions regarding semen donors and sperm banks, require donors to be tested for any causative agent of AIDS at the time of the donation. See Illinois *Compiled Statutes, Annotated* (1994), sec. 20: 2310/55.46(c) and Delaware *Code, Annotated* (1993), sec. 16: 2801(b). However, there is no mention of quarantining the semen for six months or retesting of the donor. Maryland's provisions are less broad, requiring testing for HIV but not possible causative agents of AIDS. *Annotated Code of Maryland* (1993), sec. 18–334(b)(1).

27. Indiana requires testing for syphilis and hepatitis B in addition to HIV. See Indiana *Statutes, Annotated* (Burns 1994), sec. 16-41-14-5(a)(1)(2)(3). In addition to the tests required in Indiana, California also requires testing for hepatitis C and human T lymphotrophic virus-1 (HTLV-1). See California *Codes, Annotated* (Deering 1994), sec. 1644.5(a). Florida requires testing for HIV and other communicable diseases specified by the Department of Health and Rehabilitative Services. See Florida *Statutes* (1993), sec. 381.0041(1). Kentucky requires testing for HIV and other communicable diseases as specified by the United Network for Organ Sharing, the American Association of Tissue Banks, and the Eye Bank Association of America. Ohio requires a thorough medical examination of the donor and suggests that "the laboratory studies may include, but are not limited to, venereal disease research laboratories, karotyping, GC culture, cytomegalo, hepatitis, kem-zyme, Tay-Sachs, sickle-cell, ureaplasma, HTLV-III, and chlamydia."

28. HIV is detected when an individual's blood tests positive for antibodies to the disease; hence the term "HIV-positive." If a person becomes infected, it usually takes approximately six months for the antibodies to appear in the blood. During those six months, they could transmit the virus, even though their blood tests negative for antibodies to HIV.

A New Paradigm," *Politics and Life Sciences* 12 (August 1993): 191–92.

15. Cheri Pies, *Considering Parenthood* (San Francisco: Spinsters/ *Aunt Lute,* 1988), 187.

16. Although in some states, to sever the donor's rights to paternity, a physician must perform the insemination. Nancy E. Roman, "Law on Artificial Insemination Is Still in Infancy: Rights, Responsibilities Evolving," *Washington Times,* 14 February 1994, final edition. See also California *Civil Code, Annotated* (Deering 1994), sec. 7005.

17. "Fertility Doctor Found Guilty of Fraud," *Chicago Tribune,* 5 March 1992, sec. 1.

18. Mary Ann Chiasson, Rand L. Stoneburner, and Stephen C. Joseph, "Human Immunodeficiency Virus Transmission through Artificial Insemination," *Journal of Acquired Immune Deficiency Syndromes* 3 (1990): 69–72.

19. Leslie Berkman, "HIV Peril in Artificial Insemination Cited; Health: Woman, Infected by Carrier of Virus That Causes AIDS, Urges Others to Make Sure That Clinics Do Proper Tests," *Los Angeles Times,* 29 April 1994, Orange County edition.

20. *ter Neuzen v. Korn,* 41 ACWS 3d 432 (1993).

21. *Brown v. Shapiro,* 472 NW 2d 247 (1991).

22. "Sperm Washing Study Encouraging but U.S. Researchers Leery of Risks," *AIDS Alert* 8 (April 1993): 53.

23. Two women became pregnant and miscarried but became pregnant again, so there was a total of seventeen pregnancies. Augusto E. Semprini, Paolo Levi-Setti, Maddalena Bozzo, Marina Ravizza, Anna Taglioretti, Patrizia Sulpizio, Elena Albani, Monica Oneta, and Giorgio Pardi, "Insemination of HIV-Negative with Processed Semen of HIV-Positive Partners," *Lancet* 340 (November 1992): 1317.

24. "Virginia Doctor Reprimanded in HIV 'Sperm-Washing' Case," *Aids Weekly,* 12 October 1992.

25. Reports of the transmission of sexually transmitted diseases from donor semen can be found in any of the following: William R. Berry, Ray L. Gottesfeld, Harvey J. Alter, and John M. Vierling, "Transmission of Hepatitis B Virus by Artificial Insemination," *Journal of the American Medical Association* 257 (February 1987): 1079–81; Laurene Mascola, "Semen Donors and the Source of Sexually Transmitted Diseases in Artificially Inseminated Women: The Saga Un-

Notes

NOTES TO CHAPTER ONE

1. Chris Mihill and Sally Weale, "Birth Pangs: Has Fertility Treatment Set the Rights of the Unborn Child against Those of Desperate Parents?" *Guardian,* 5 January 1994.

2. There is apparently no comparable term for older men who become fathers.

3. Elizabeth Noble, *Having Your Baby by Donor Insemination* (Boston: Houghton Mifflin, 1987), 87.

4. Noble, *Having Your Baby,* 87.

5. Noble, *Having Your Baby,* 87–88.

6. Noble, *Having Your Baby,* 88.

7. Noble, *Having Your Baby,* 89.

8. Noble, *Having Your Baby,* 106.

9. Sally Squires, "When the 'Father' Is a Sperm Donor: Shopping for Safe Sperm," *Washington Post,* 11 February 1992, final edition.

10. "Canadian Artificial Insemination Study Warns of HIV Risk," *Reuters,* 28 April 1993, British Columbia cycle.

11. Robin Schatz, "Risky Business: Unlicensed Sperm Bank Faces Charges," *Newsday,* 26 April 1992, city edition.

12. Office of Technology Assessment, 100th Cong., 2d sess., *Artificial Insemination Practice in the United States: Summary of a 1987 Survey.*

13. Jeff Stryker, "Artificial Insemination Is More Widely Available—and More Problematic," *Dallas Morning News,* 12 October 1993, final home edition.

14. Barbara Raboy, "Secrecy and Openness in Donor Insemination: